EDINBURGH TRAMS
THROUGH TIME
Keith Anderson

AMBERLEY

Acknowledgements

A book spanning some 150 years of transport history is no light undertaking, and I simply could not have achieved this without the support of the following organisations, individuals and keepers of heritage images, which I gratefully acknowledge: Transport for Edinburgh, Network Rail Scotland, CAF, the Tramway and Light Railway Society, Street Crane, AHR architects (formally AEDAS), Simon Fozard (late John Fozard images), Andrew Williams (late Dewi Williams images), Peter Brabham (late Norman Hurford images), Mike Ashworth, Kyle Hulme, Glenn Innes, Alan W. Brotchie, Richard J. S. Wiseman, artist John M. Boyd and Edinburgh Arts.

First published 2014

Amberley Publishing
The Hill, Stroud
Gloucestershire, GL5 4EP

www.amberley-books.com

British Library Cataloguing in Publication Data.
A catalogue record for this book is available from the British Library.

ISBN 978 1 4456 4362 5 (print)
ISBN 978 1 4456 4397 7 (ebook)

Typesetting and Origination by Amberley Publishing.
Printed in Great Britain.

Contents

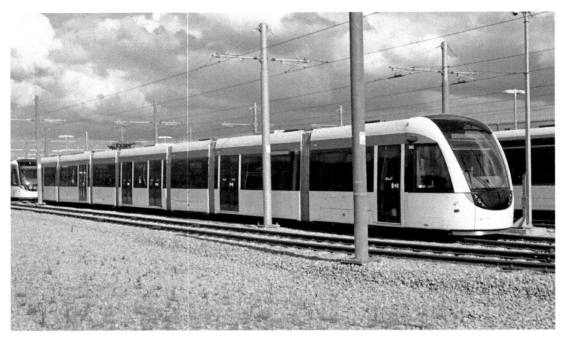

Open storage of the CAF Urbos 3 tram fleet at Gogar Depot.

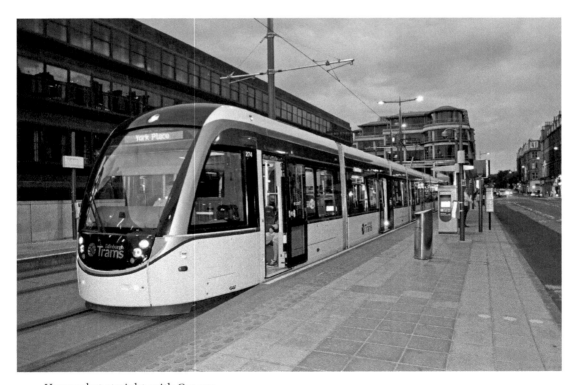

Haymarket at night, with Car 274.

Introduction

This book is the condensed and illustrated story of Edinburgh's love affair with trams. Early horse-hauled trams couldn't cope with city hills, and thus cable trams commenced in 1888; a new operator had converted the network to cable by 1907. Conservation reasons contributed towards Edinburgh being the largest British cable tramway long after other tramways made the switch to electric traction. Direct municipal operations began in 1919, successfully electrifying and expanding the system before post-war policy resulted in scrapping the tram network in favour of bus operations. An award-winning bus service helped stave off the need for trams until various studies identified the tram as a key component in countering increased road congestion. The city made questionable decisions concerning early opportunities for a return to tram operations until adopting the current scheme. After considerable construction delays, cost overruns and disputes, the initial tramway, half the planned length at twice the forecast cost, opened in May 2014, linking the airport with Haymarket, Princes Street and York Place.

The Through Time series serves to illustrate history in ninety-six pages, which inevitably means compression; this is particularly so with the fine legacy tramways, for which a bibliography is provided, with recommended sources offering greater detail. Victorian-era companies have a tendency to adopt long titles; where appropriate these have been abbreviated.

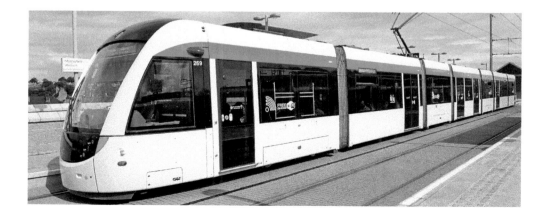

1

Edinburgh Before Trams

Mid-nineteenth-century Edinburgh remained a relatively compact and dense city, where work was generally located near to living quarters and initial transit options served only the minority able to afford the luxury of travel. It was the demand for coal, horse hauled from nearby coalfields, that created the first rail connections. Later steam railway booms resulted in ever speedier links with the rest of Britain. Railways encouraged emigration to urban centres, and Edinburgh's population more than doubled, from 103,143 to 222,059, between 1811 and 1881. The working classes became increasingly crammed in poor housing, where landlord exploitation and unsanitary conditions were rife, resulting in recurring outbreaks of disease. During the city's worst ever recession from 1825 to 1860, a period notorious for negligible new housing, work remained particularly scarce.

Various attempts were made to alleviate overcrowding, including the Railway Regulation Act of 1844, which introduced cheap third-class rail fares, an effort to encourage a shift to suburbs offering cheaper and healthier accomodation. Edinburgh had to wait until the southern suburban line (1884) and dock service opened to provide passenger transit options; even so, the city lacked a cohesive network of suburban stations. Horse buses were active from 1830 and filled the void; popular and crowded at peak periods, their changes were not universally appealing.

Unhealthy areas are constantly being demolished, with the result that the workers are driven from the slums and rookeries where they used to herd. They are thus being more and more forced to live in the suburbs of great cities; and cheap, rapid and regular means must be provided to convey them to and from their work.

('Municipal Trams', *Fabian Tract No. 33*, Feb. 1898)

In general the horse bus was a middle-class conveyance, and did not derive its revenue from the artisan classes. The latter normally walked to and from work, even when journeys of some miles were involved, until the 1880s and 1890s, and then were served by tramcars and workman's trains.

(Charles Edward Lee, *Horse Bus as a Vehicle*, 1962)

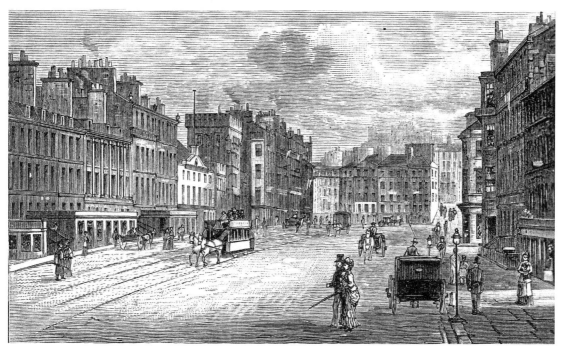

An 1880s etching, showing horse trams on upper Leith Walk heading towards Bernard Street.

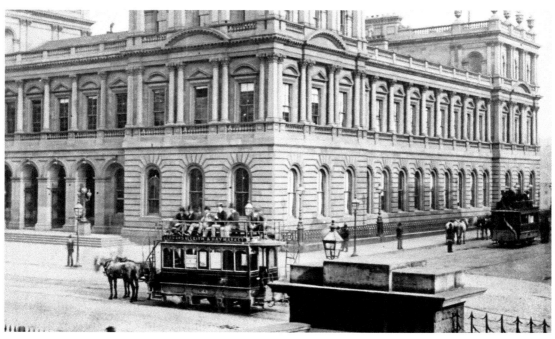

Edinburgh's first tramway at the post office. Note the knifeboard upper seating and precarious steps provided. (Tramway and Light Railway Society)

Horse-bus operators were entrepreneurs, not interested in any egalitarian advances in public transport. Despite shortcomings, the horse bus pioneered routes and provided the first recognisable stopping service from railway terminals and port commercial centres to the quickly expanding suburbs.

The early horse bus was also limited by horse range. The city roads were not sealed and were far from the smooth surfaces we take for granted now. Wagon ways proved that low-running-resistance steel wheels on steel rails meant the same horse resource could pull similar loads up to 20 miles in a day. Thus, trams had the advantage of greater passenger capacity for the same given horsepower resources, which meant significantly lower fares. Overheads associated with horse-bus operation meant they usually couldn't compete directly with tramways.

An EST Co. early horse tram near the GPO, with single steps to the upper deck. (Tramway and Light Railway Society)

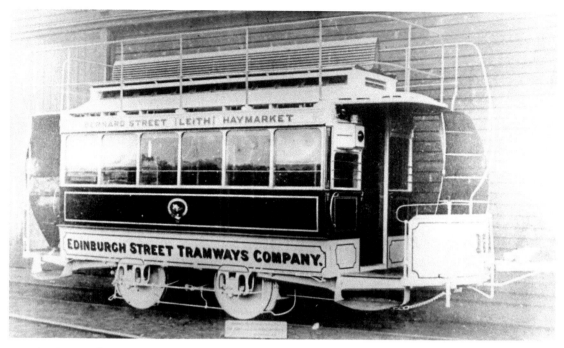

An EST Co. horse car with added grab rails and external oil lamp. (Tramway and Light Railway Society)

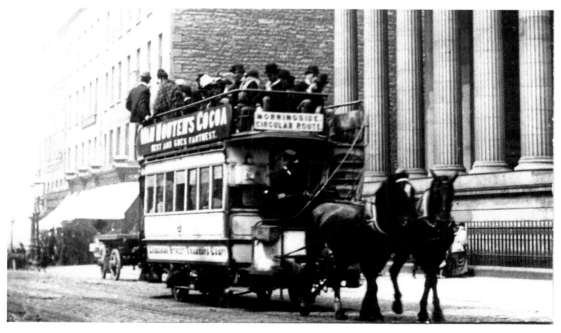

Capacity-loaded Morningside circular horse tram passing Surgeon's Hall. (Tramway and Light Railway Society)

2

First-Generation Tramways

The first instance of passenger-carrying trams was the Swansea & Mumbles Railway in 1807, where converted mineral wagons fitted with seats enabled the railway to overcome the area's lack of roads. In 1832 the potential for conveying urban passengers by horsepower was fully realised in New York. In Europe, Paris had begun horse-tram operations in 1855. Britain's first urban street trams were the work of American entrepreneur George Francis Train, who established a series of pioneering British tramways, although not all would prove lasting successes, with London magistrates fining him for 'breaking a street', before ordering the removal of his rails, which obstructed other traffic, due to their raised lips.

Recognising the potential of tramways, yet wary of the pitfalls besetting earlier railway and canal booms, the government approved the Board of Trade Tramways Act of 1870. An Act that ensured future British tramway plans and extensions, it satisfied Parliament and met with municipal approval, as their promoters had the necessary resources to complete what they started and the operations met the Board of Trade's requirements.

The Act empowered local authorities to regulate tram operations as they had the horse-bus or cab traffic and endeavoured to maintain tram routes by offering a choice of track-ownership arrangements but prevented direct municipal operations for the first twenty-one years. Two choices of track ownership were offered: if the operator built the track then they were responsible for the upkeep of that part of the road; alternatively, if the local authority built the line then they maintained the entire road in return for an additional levy over and above the agreed annual concession charge. This arrangement meant both parties were obliged to maintain positive relations with one another, despite having diverse aims: the company sought profit while the council, accountable to the local electorate, often held an interest in widening access to public transport. Also, the so-called 'scrap iron clause' at the end of the lease stated that the council had the right to purchase at asset value and not at going concern rates as was the normal business route. Thus the roots of future schism and of leaseholders lacking investment incentive towards the end of leases were sown.

The twenty-one-year tram leases were highly coveted, since they attracted custom from the fragmented, often cut-throat horse bus operators; unlike the railways, 'me too' competitors were unlikely to appear on similar routes. Trams had a number of advantages – they were operational in all weathers, and offered greater carrying capacity, more speed and increased economy

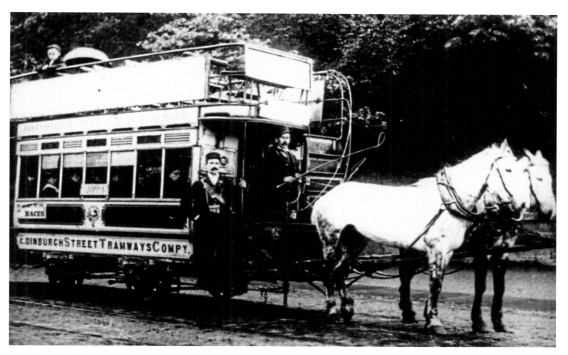

An EST Co. horse car with garden bench seating. (Tramway and Light Railway Society)

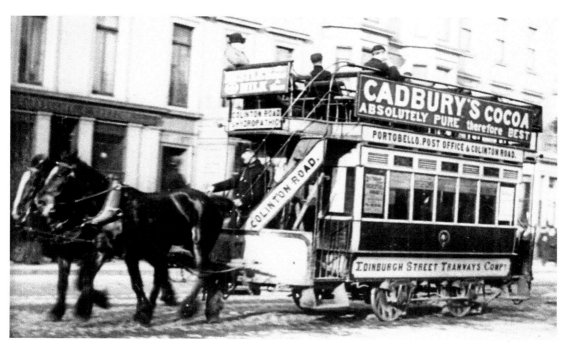

An EST Co. horse car, with advertising competing with the destination boards. (Tramway and Light Railway Society)

– making it almost impossible for sustained horse bus operations on the same route. Thus a well-run tramway would prove an attractive investment, with yields of 7 per cent envisaged in contrast to the typical 3 per cent offered by the inherently riskier railways.

Edinburgh's Horse Tramways

In 1870 Edinburgh received two separate bids from promoter syndicates. After deliberations between the parties, agreement was reached, resulting in the submission of a single bid. The Edinburgh Street Tramways Company (Street Co.) secured rights to deploy their horse-hauled trams in the city and, as Leith Town Council was also party to this arrangement, in Leith also. Street Co. secured the lease with the passing of the Edinburgh Tramways Act 1871; by November they had commenced services between Haymarket and Bernard Street, Leith, a route pioneered by horse buses running on a five-minute frequency tracing its origins to 1863.

This 3¼-mile route traversed Leith Walk and Princes Street, deploying imported cars on the 4-foot-8½-inch-gauge, or standard gauge, track, which had not been changed in over eighty years of continuous tram operation. Fares again reflected established inside or outside carriage options, commencing at 1d per mile with a maximum 3d ticket. Offering a peak six-minute service, the line was an instant success. Street Co. proceeded to expand, constructing additional lines on the emerging commuter runs, such that by mid-1875 over 13 of the total 18½ miles of track commissioned during their lease were being worked.

The council had insisted upon a clause necessitating provision of workmen's trams, a milestone attempt at inclusion, but this proved an unworkable arrangement. The company was required to offer compensation to horse bus proprietors they displaced, a number of whom subsequently switched to tram contracts. In 1873, horses averaged 5.8 miles/day and the average cost was 7¾d/mile. Car staff initially worked seventy-six-hour weeks (sixty-eight from 1889), and wages were between 20s and 26s per week. Pay and conditions were major concerns for early activists like the Fabian Society, who took the following view:

> The companies are organisations of capitalists for running tramways as a means of gaining profits. They only care for big dividends; and dirty cars, high fares, and shamefully overworked drivers and conductors are matters of quite secondary importance. ['Municipal Trams', *Fabian Tract No. 33*, Feb. 1898]

The horse tram was certainly an advancement in terms of comfort, speed and efficiency, but by necessity these pioneer tramways had to avoid challenging gradients such as those encountered in Stockbridge, the north and south approach to George Street, and the Mound, etc., while lesser gradients were achieved through the provision of 'trace' horses.

The company also became a horse bus operator in its own right, initially to extend the reach of its lines. With the expansion of horse-powered transit, the city streets were subject to increased volumes of horse droppings, and there were concerns that the widespread exposure to such effluent might be linked to increased child mortality rates.

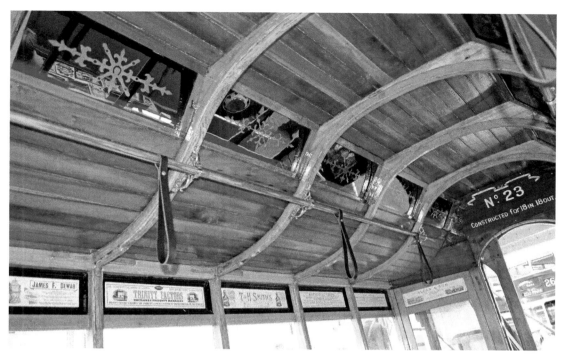

Car 23 fully restored at the Scottish Vintage Bus Museum, Lathalmond. (EDT Co.)

Car graphics. (EDT Co.)

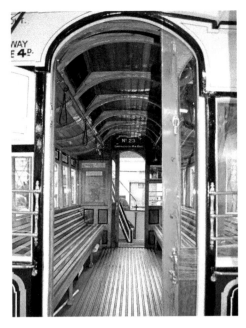

Car 23, discovered in a Borders garden where it had spent the last 100 years as a shed.

Different livery reflecting past ownership. (EDT Co.)

Dividend Payments: Edinburgh Street Tramway Co. Compared with Glasgow

Company	Track Length (1893)	1888	1889	1890	1891	1892	1893
Edinburgh Street Tramway Co.	18.12 miles	6%	6%	6.75%	5%	5%	5%
Glasgow Tramways Co.	30.25 miles	10.5%	8.33%	8.33%	6.66%	5%	5%

Consistent and better than average dividends ensured Street Co. shareholders remained loyal. Not surprisingly, management wished to retain this lucrative lease. When Edinburgh council announced their intention of taking possession of the system in August 1890, Street Co. responded by offering lower fares, the introduction of mechanical power, enhanced annual way leave payments and a share of profits over 6 per cent. Edinburgh council could not be swayed and proceeded to acquire the entire track within their boundary, with the exception of the younger Waterloo Place–Leith line. The council ignored a last-ditch Street Co. offer worth £10,000 a year to the city and put the running of their lines out to open tender.

Edinburgh's unilateral action was not welcomed. In Leith, the town council favoured a unified approach and would have looked upon possible joint ownership, which was likely to be extended to include Portobello, favourably. This left the smaller boroughs with no alternative but to accept enhanced terms offered by Street Co.

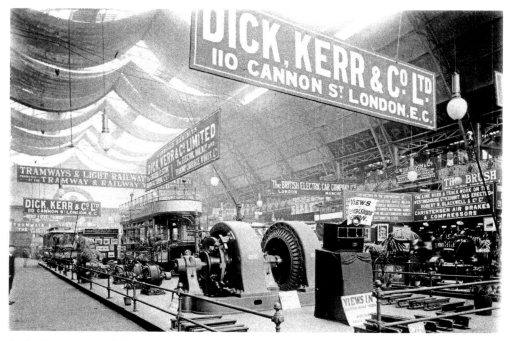

Dick, Kerr & Co. exhibiting at the Tramways & Light Railways exhibition held at the Royal Agricultural Hall, London, July 1902. (Author's collection)

The tender indicated a requirement of 7 per cent rental on the final price paid for Street Co. assets, maintaining the system, reduction in the staff working hours to fifty-four hours/week plus taxes and feu duties. Three serious bids were put to the council:

Street Co. took the view it was all about finance, thus increased their final offer to £13,000 p.a. plus 7 per cent on new cable routes (others by consultation), but insisted upon maintaining their existing staff working hour arrangements.

Glasgow Tramways Co. were in a similar predicament to Street Co., having built up a superb network that Glasgow council now intended to run directly. Under the circumstances it is conceivable they may have tabled a generous offer; equally it may be construed that Edinburgh council did not wish a repeat of the west coast council versus company saga – either way, their offer was declined and never made public.

Dick, Kerr & Co. Ltd Contractors, London, also controlling owners of the Edinburgh Northern Tramway Co., already had two working cable lines on Edinburgh routes unsuited to horse power. They saw great opportunity for corporate advancement by accepting the terms, with the added sweetener of proposing a forty-four-hour staff week and penny fares where cable traction was brought into operation.

The council, having enjoyed a good experience with Dick, Kerr, voted to accept their offer in October 1893. The Street Co. assets were acquired for £185,000 and transferred to Dick, Kerr at the agreed 7 per cent return. Since local authorities lacked powers for direct operations, Edinburgh appears to have achieved great business, having borrowed capital at 3 per cent, thus all but guaranteeing a profitable franchise, securing the promise of new routes, lower fares and introduction of new technology – overall, a deal many other boroughs could only dream of imitating.

Dick, Kerr officially took over the Edinburgh lease, consisting of 11¾ miles of track, sixty cars and some 600 horses, on 3 December 1893. Several months later the council was persuaded to accept a change of name to Edinburgh & District Tramway Co. Ltd, but only after Dick, Kerr guaranteed to stand behind their franchise's 7 per cent annual payment. The company was engaged in a wide variety of commerce, from shipping to extensive light rail interests, and therefore significant capital requirements. Dick, Kerr opened a Preston factory to manufacture trams in 1893. Given their competitive nature it was no surprise they won various tenders to renew track and install cable traction in Edinburgh.

Edinburgh's Cable Tramways – Northern

The increased mechanisation evident towards the end of the Victorian era made it inevitable that horses would be replaced; indeed, Kitson steam engines actually hauled trams in Portobello between 1881 and 1882, but their poor reliability, public dislike of proximity to smoke, and fear of engine explosion meant they were never a real contender to replace horse traction.

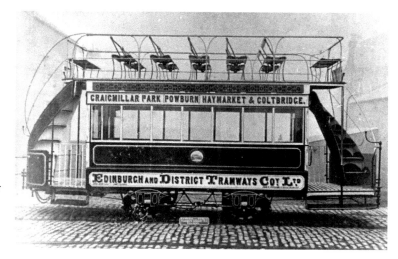

EDT Co. took over former Street Co. facilities, including trams. (Tramway and Light Railway Society)

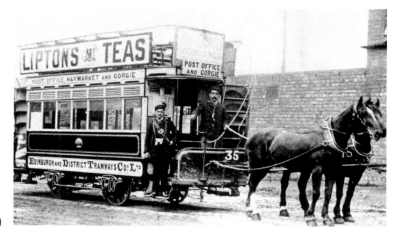

Horse Car 35, after a hard day's travel. (Tramway and Light Railway Society)

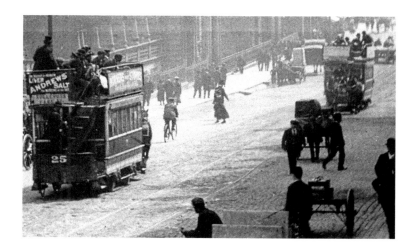

Early 1900s horse cars are now widening their appeal. (Tramway and Light Railway Society)

In 1878 a cable tramway was successfully worked in San Francisco. Not only could cable haul up inclines horses couldn't cope with, but cable haulage costs were proved to be less than half the horse rates per mile.

Dick, Kerr promoted a Bill to Parliament in 1883 for a series of Edinburgh routes. Successfully securing council consent, the Edinburgh Northern Tramways Company (Northern Co.) was formed in August 1885. The Act of Parliament indicated a choice of traction, either rope or electric, since the proposed lines were well away from Street Co. and thus considered a bonus. Commencing in Hanover Street, the first line opened in January 1888 to Trinity, and a second ran from Fredrick Street to Comely Bank via Stockbridge the following year. Both routes were located close to Princes Street, but stopped short of crossing Street Co. tracks.

Cable traction was a long, sometimes 6-mile, length of cable joined at its ends to create a cable ring. Cable moved at a consistent rate, though speeds varied between lines depending upon inclines, within an embedded protective steel conduit with only a 16-mm-wide slot visible. Entanglement with other road users was thus virtually eliminated. Cable cars moved forward by 'gripping' the cable by means of a clutch device, and slowed down by releasing the tram's grip on the continuously moving cable. The cable was guided around curves and inclines by use of embedded rolling shelves or angled cogs. Operationally, cable traction costs were less than half that of comparable horse-hauled trams. Indeed, Northern Co. chief engineer William Colam later stated their advantage thus: 'The average speed of cars is under the circumstances, faster, and service more frequent, than it could be with horses.' (Proceedings, Incorporated Association of Municipal and County Engineers, Volume XVII. 1890–91. (London, England).)

Cable traction was derived from a central powerhouse whose coal-fed boilers created the steam energy to drive the cable pulley and associated mechanism. Northern Co. housed their cars and powered cables from their newly commissioned Henderson Row power station, serving 6 miles of cable line and some fourteen cars.

Edinburgh's Cable Tramways – District

In 1896 only four methods of powering trams were recognised: horse, cable, steam and electric. Electric offered two options: overhead wire or ground contact; the latter, together with the steam-hauled tram option, was feared from the safety aspect, but neither was ever a serious contender in Edinburgh. After intense debate, Edinburgh decided to expand, with the now familiar cable traction; this was viewed as an advance on the horse-hauled tram, and its only weakness was the requirement for ongoing continuous expert maintenance and periodic replacement of worn-out cables, which meant retaining expertise.

One of the benefits taken for granted under the initial operator was the provision of a unified service over the various boundaries worked. The main tram artery between the Edinburgh and Leith systems met at Pilrig Street on Leith Walk. Initially they had hoped to offer some through working arrangement, but the combination of two tramways under two authorities with different traction systems, i.e. initially horse one side and cable the other, made this impossible. The respective operators lacked the powers to resolve the matter; the authorities could have reached an accord but, in what must go down among the most bizarre incidents of public transport failure, never reached agreement. The impasse became known as the 'Pilrig muddle',

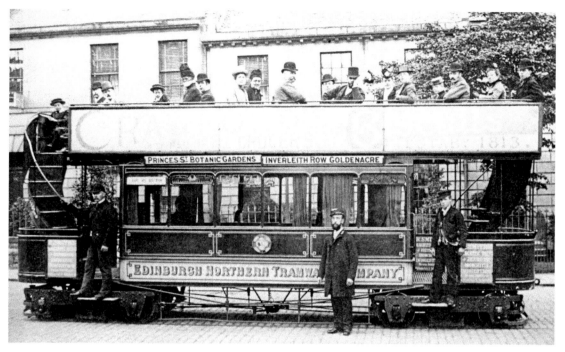

The innovative cable car of Edinburgh Northern Tramway Co. at Inverleith Row, 1897. (From the collection of Alan W. Brotchie)

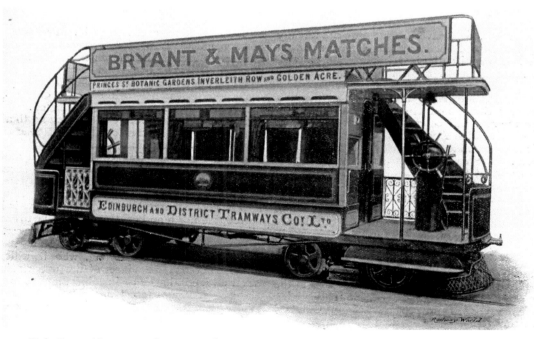

Dick, Kerr cable car on a former Northern Tramway route. (Tramway and Light Railway Society)

An EDT Co. Trinity-bound cable car. (Tramway and Light Railway Society)

Horse tram near Waverley steps, Princes Street, at the height of the horse power era. (Tramway and Light Railway Society)

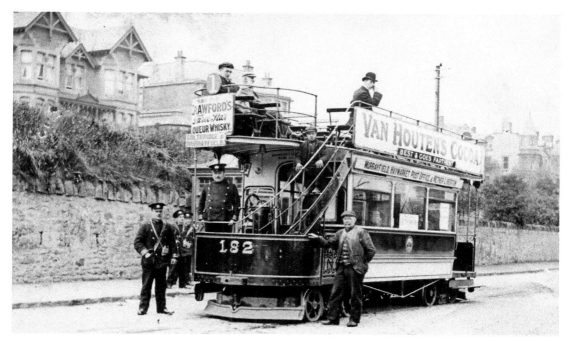

Staff and passengers pose on the Murrayfield line. (Tramway and Light Railway Society)

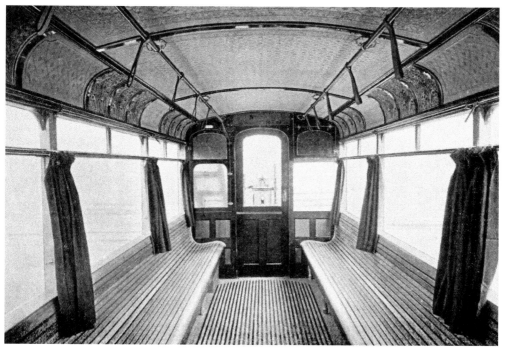

Interior of cable car, showing the rudimentary seating, ornate panel decoration and ceiling grab straps. (Tramway and Light Railway Society)

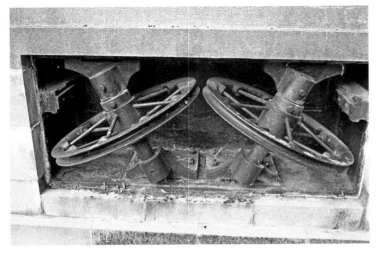

Preserved Henderson Row power station cable pulley arrangement.

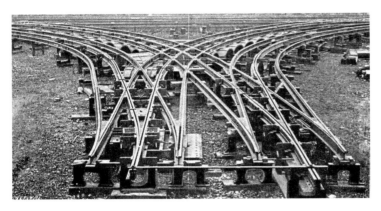

New track and cable conduit arrangement for Register House junction. (Tramway and Light Railway Society)

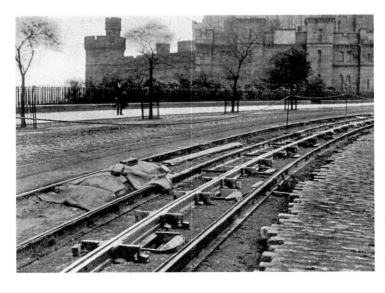

Track, conduit and pulley installation near Carlton jail. (Tramway and Light Railway Society)

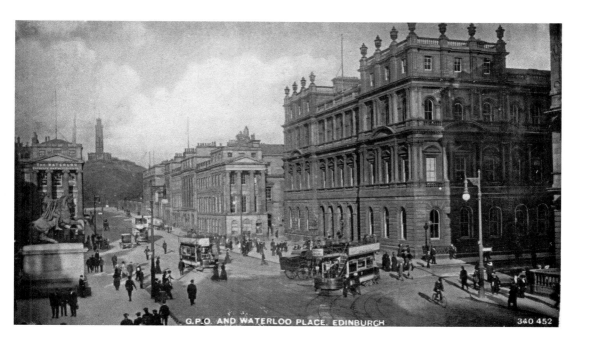

Above: Evening postcard view of east Princes Street and the now installed Register House rails. (Author's collection)

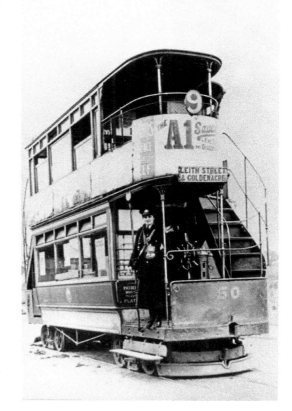

Right: The EDT Co. number 9 service. The conductress suggests that the image was taken during the First World War. (Tramway and Light Railway Society)

EDT Co. built Tollcross as a cable power station, but it also housed trams. (Tramway and Light Railway Society)

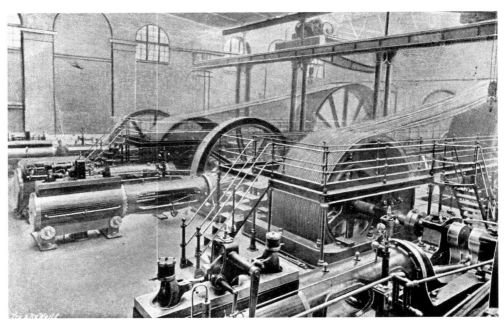

The Tollcross steam-powered cable mechanism was cutting-edge technology for its day. (Tramway and Light Railway Society)

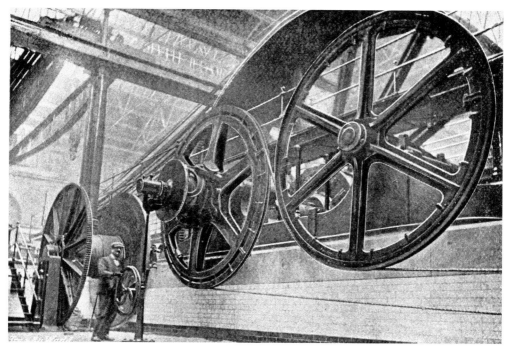

An enhanced view of the cable driver, idler and pulleys. (Tramway and Light Railway Society)

Tollcross deployed a travelator to help maximise limited car storage space. (Tramway and Light Railway Society)

and remained unresolved until both authorities merged and the route was fully electrified in 1920.

It is rather remarkable that cable powered Edinburgh trams from 1888 to 1922 given the narrow, twisty and often inclined nature of the city's streets. The opposition to 'obstructive' overhead wiring apparatus doubtless contributed towards this becoming Britain's largest and longest-running cable tramway. Nowadays cable might sound archaic, but at the time, with electrical trams still in their infancy and before a dependable source of electrical supply, cable haulage was viewed as an advance on horse power and a serious challenger to electric trams.

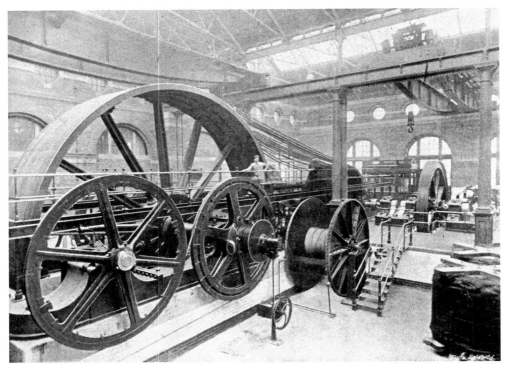

Shrubhill cable power station, with the complex array of flywheels and pulleys needed to haul the cable. (Tramway and Light Railway Society)

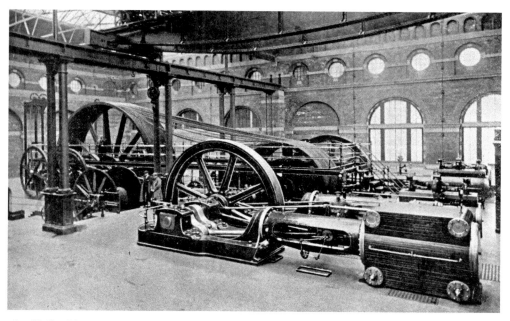

Shrubhill cable power station kept local cable routes running. (Tramway and Light Railway Society)

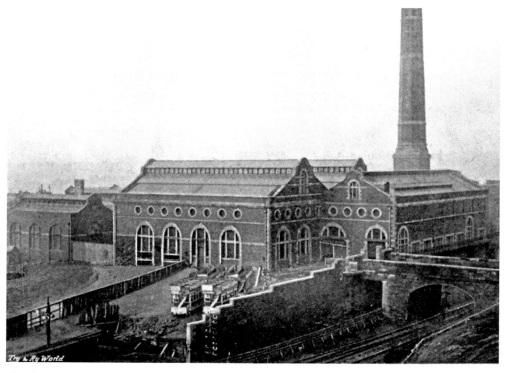

Shrubhill had served multiple roles: power station, car production workshop, car shed. This view shows coal access. (Tramway and Light Railway Society)

Cable cars on Princes Street. (Author's collection)

Cable cars outside of the famous North British Hotel. (Author's collection)

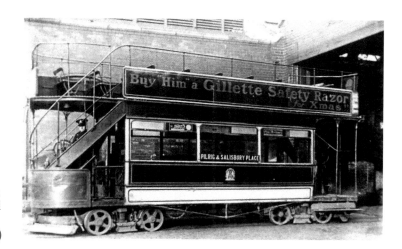

A cable car in Corporation livery, featuring a seasonal advertisement. (Tramway and Light Railway Society)

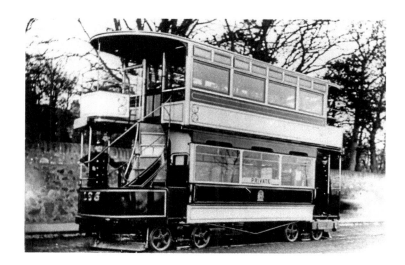

An example of an early balcony-ended enclosed upper car. (Tramway and Light Railway Society)

A 1950 image of the former cable-era track at Waterloo Place. (Dewi Williams)

3

Municipal Tram Era

Leading up to Edinburgh's municipal tram era, a number of significant events occurred. The Light Railways Act 1896, the same year that the adjoining Portobello borough was absorbed by the city of Edinburgh, enabled local authorities to own and operate tramways. After debate the council voted in July 1919 to acquire most of the District Co. tramlines within its boundaries. In 1920 the Edinburgh Boundaries Extension & Tramways Act enlarged the city in several directions, including the borough of Leith, despite the former town holding a plebiscite opposing amalgamation. The Boundaries Act also ensured the merger of the respective tramway operations, which finally put an end to the Pilrig muddle.

The enlarged Edinburgh was responsible for commissioning the much-needed advanced high-output Portobello power station, strategically located near railway sidings on the coast. The commissioning of this gigantic structure enabled replacement of the patchwork of less efficient, aging coal-fired power stations. Coming on stream in 1923, Portobello immediately banished the de facto rationing, producing more than enough energy to run all of Edinburgh's trams, street lights, industrial and domestic needs.

The 'scrap iron clause' of the Tramways Act of 1870 enabled local authorities to compulsorily purchase tram undertakings at a significant discount to going concern rates. This clause was intended to ensure councils were not overburdened with debt when they commenced municipal transport services. Knowing their days were numbered and wary of this clause, company leaseholders often deferred all but essential operational expense. Not surprisingly, even before the First World War, there was public concern about what was widely considered a deterioration of the tram service.

'The Edinburgh cable car system is the slowest, roughest, noisiest, dearest, least adequate and worst-lighted system in existence. There is nothing like it elsewhere – it is unique.' (Mr J. C. McRitchir, *Scotsman letters*, 14 Nov. 1911)

The war had a detrimental impact on the service. Materials shortages caused great difficulty; worn cable replacement was impossible, necessitating retention of otherwise scrap lengths continually patched in an effort to maintain services. Long-serving drivers and maintenance staff had left for national service, and their replacements were inexperienced. Women filled in more than adequately for conductor roles, but new tram drivers caused havoc with cable breakage, and each incident brought the entire line to a halt for many hours. Similarly, lack of experience in maintenance teams meant that by 1916 some 5,000 out of a total of the

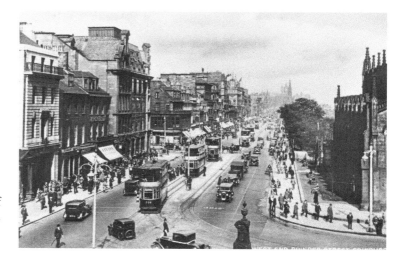

Princes Street West End, featuring mixed modes of transport: trams, cars and horse traction. (Author's collection)

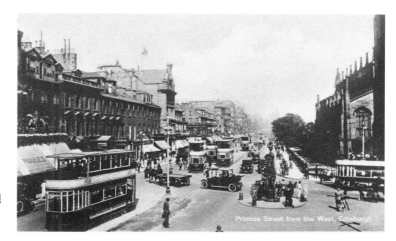

Princes Street, with mixed open and enclosed upper cars. (Author's collection)

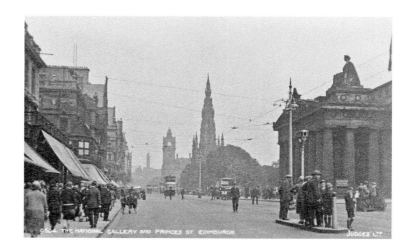

Princes Street Mound junction trams and early motor buses; the horses have gone. (Author's collection)

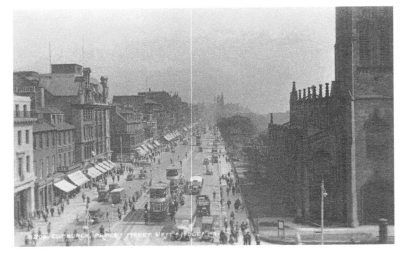

Princes Street, 1930s, with busy loading islands awaiting trams. Buses remain single deck. (Author's collection)

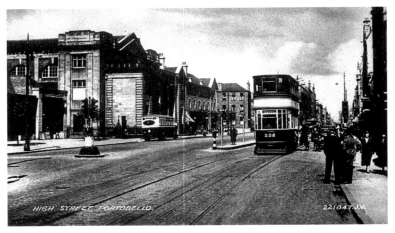

Cable reached as far east as Joppa, and is seen here at Portobello High Street. (Tramway and Light Railway Society)

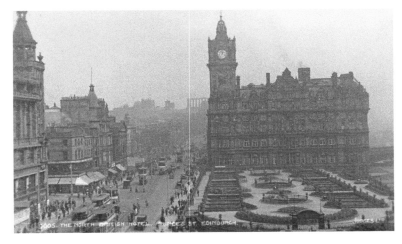

The North British Hotel overlooking increased tram and car traffic. (Author's collection)

network's 13,000 cable pulleys were either defective or in some need of repair. That same year *The Scotsman* ran an article on the trams, headed 'the collapse of the service'. After the war, in April 1919, Edinburgh council debated the future of their tramways. The proceedings noted the continued deterioration of the cable service, as these extracts (again from *The Scotsman*) serve to illustrate:

> No community had been so long suffering or had suffered such irritation from its tramway system as Edinburgh had done for three months [Reference to beginning of 1919] ... the days of cable cars had ended and the sooner the Council addressed itself to question what was to be put in place of this system the better ... all very well for the Tramway co. to blame the war; but they all knew that before the war the streets were in a bad condition and that the company had always delayed making repairs until they were kicked into doing them.

The council's tramway committee recommended the immediate adoption of electric traction, citing a conclusive economic argument that electric trams were capable of a cost/mile of 7*d* (up to sixty passengers) compared to 8½*d* (up to thirty passengers) for motor buses. The Committee added that at present no transport mode was more efficient than a self-propelled tram, and pointed out that buses also had a destructive impact on the road surfaces not yet factored in to already poor comparative figures.

Despite the deteriorating cable service, the city was far from unified about adopting overhead electrical trams. Some feared that cable and pole arrangements would damage the city's tourist industry by blighting sensitive visitor sights such as Princes Street and the old town. A report commissioned by the Tramway Committee, which included opinions from other municipal tramway experts, concluded that overhead wire offered Edinburgh 'the best most reliable, convenient, and economic solution'. This prompted a councillor to remark, 'If a referendum of the citizens were taken, 80 per cent would vote for the overhead electric throughout the city.'

After reaching agreement concerning the price of District Co. assets, the council became the legal tramway operator for the first time in July 1919. Material scarcity added to the headache of trying to maintain what was a dilapidated service until the switchover to electric traction became feasible.

The new undertaking was officially known as the Tramways Department (referred to here as the Corporation). The transport committee had advised the council that comparable British cities who chose to switch from horse to electric traction had almost double the tramway miles of Edinburgh, confirming that cable was only deployed where heavy traffic was anticipated, and therefore developing areas of the city were without a tram service, since the prospective traffic would not support the costs associated with cable trams.

So expansion was very much on the agenda. Cable lines were expensive and required significant traffic to justify the investment. District Co.'s last expansion plan to link the city with South Queensferry was rejected in 1918, since the traffic forecast was considered inadequate to justify the cable costs; they were also still obliged to conform to the Edinburgh Corporation Tramway Act of 1893, which stipulated that any additional extensions or a new line had to be cable hauled.

Edinburgh's first electric trams ran experimentally between Ardmillan Terrace and Slatford in 1910. The converted cable cars were towed in place daily by regular District Co. cable

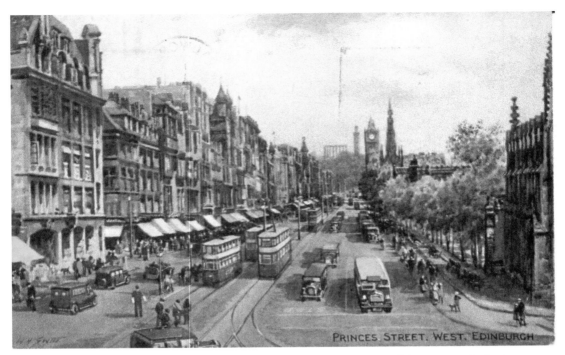

1930s Valentine's postcard art offers an early colour interpretation of the West End of Princes Street. (Author's collection)

Car 180, built at Shrubhill, attracting the attention of management and visitors. (Mike Ashworth collection)

Right: Interior view of the unfinished Car 180. (Mike Ashworth collection)

Below: New livery cars built in the 1920s passing on the bridges. (Dewi Williams)

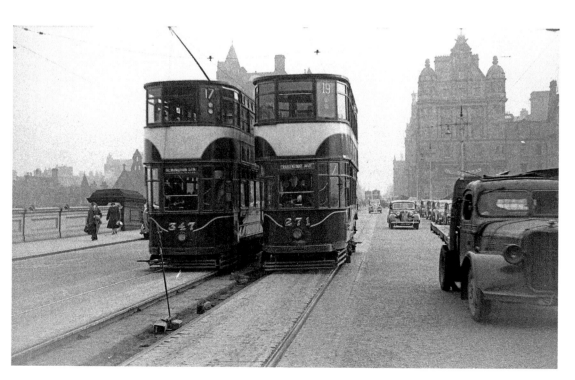

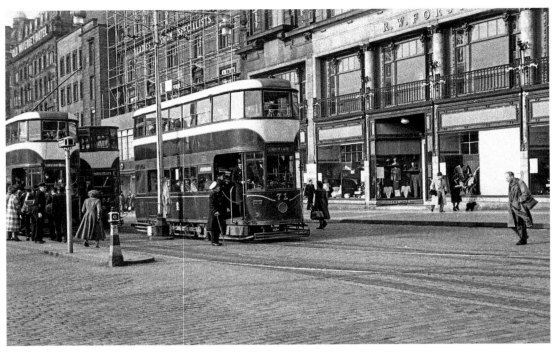

Raised waiting islands on Princes Street, 1950. (Dewi Williams)

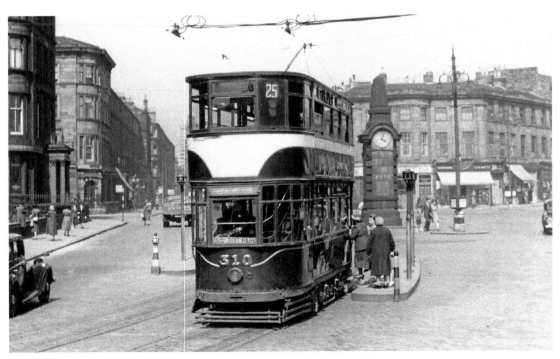

Loading at Haymarket, July 1954. (Richard J. S. Wiseman)

Loading at Waterloo Place on returning to Levenhall. Parked cars now compete for road space. (Dewi Williams)

trams based at Shrubhill depot. Two Acts of Parliament – the Edinburgh Corporation Order Confirmation Act 1919 and The Edinburgh Boundaries and Tramway Act 1920 – granted the merger and subsequent expansion for Edinburgh and Leith. Edinburgh had appointed a new manager, Stuart Pilcher, and when Leith was absorbed Mr F. A. Fitzpayne became his deputy. The Corporation tramway reduced fares, reasoning that lower prices aided the mobility of labour.

The management team, meanwhile, were tasked with delivering electrification of the existing system. This commenced in June 1922 with the through electric running from Leith to Liberton, service No. 7, bringing an end to the 'Pilrig muddle'. After much debate concerning the visual impact of overhead power lines on Princes Street, the council voted for overhead electrification, despite a vigorous campaign by those who considered elevated pole and wire arrangements to be an aesthetic impairment. Princes Street received centre poles, but elsewhere suspended wire or side poles were the norm. Edinburgh electrified rapidly; all the usable cable cars were converted to electric at Shrubhill, and former cable routes were both electrified and extended.

In 1928 Stuart Pilcher was appointed general manager of Manchester trams, and the capable F. A. Fitzpayne took his place, pressing home the extensions and expansion programme, but he died in March 1935. This necessitated the appointment Robert McLeod, whose pre-war achievements included a significant expansion of the Leith depot and what was to prove the last tramway extension, from Corstorphine to Maybury in February 1937. Between the wars, the management had presided over the greatest expansion of Edinburgh tram network, culminating in what was to be the world's fifth-largest tramway service. Demand was such that it overwhelmed the

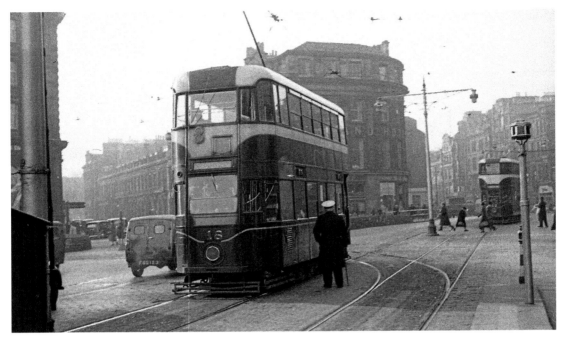

A Hurst Nelson (later Metro-Cammell) Streamliner car bought in the 1930s to help meet demand. (Dewi Williams)

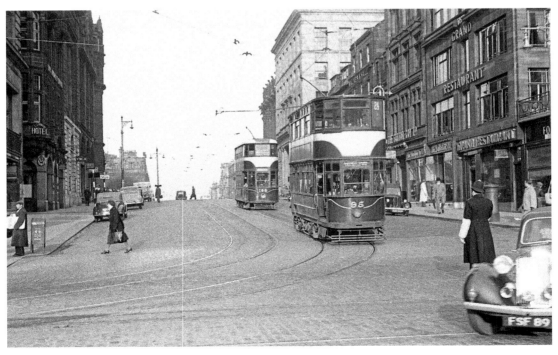

Seamlessly blended rails between South St Andrew Street and Princes Street. (Dewi Williams)

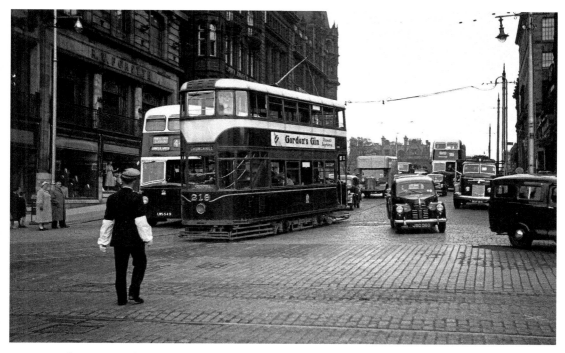

St Andrew Street during rush hour. (Simon Fozard collection)

Eastbound traffic at York Place. (Simon Fozard collection)

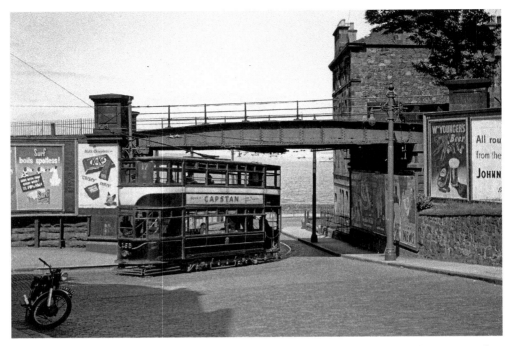

Tram traffic lights were a necessity to negotiate the single-track 'S' bend beneath Trinity Bridge. (Simon Fozard collection)

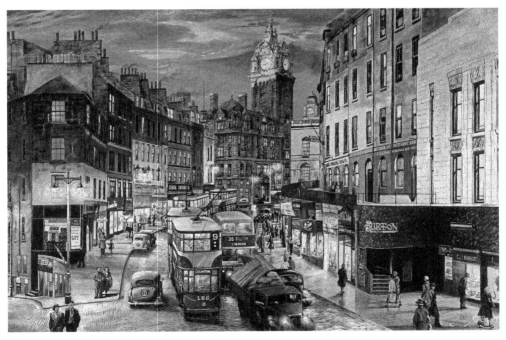

A John M. Boyd view of a bustling evening rush hour on Leith Street. (By kind permission of Edinburgh Arts)

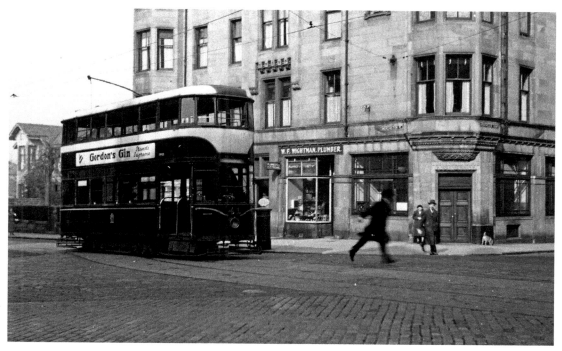

Stationary Car 41 at Marchmont Place, early 1950s. (Simon Fozard collection)

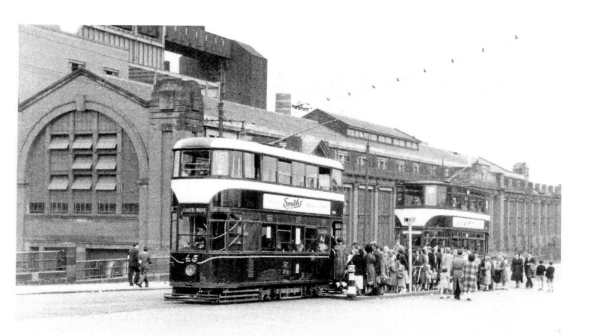

Portobello day trippers heading home, overlooked by the massive Portobello power station, 1953. (Richard J. S. Wiseman)

production of Edinburgh standard tramcars at Shrubhill, necessitating various batches of both new and, finally, second-hand cars to be bought in to meet demand.

The outbreak of the Second World War proved another challenging period. Edinburgh was fortunate not to be intensively targeted, but bombs killed eighteen, causing over 200 injuries around the city; the resultant manpower void was partially filled by conductresses. The wartime performance was, given rationing, etc., exemplary, and the electric tram fleet proved more resilient to the inevitable staff turnover. Pre-war investments such as Portobello power station ensured the service came through in better shape than in 1919, and gave the capability to handle peak tram traffic of 193 million passenger trips achieved in 1947. Despite this performance, after the war the tide turned decisively against the tram in many British towns, largely as a result of motor buses becoming cheaper to produce and the greatly enhanced road surfaces being more amenable to their widespread use.

From 1950 onwards, residents attending ward meetings made known their desire to retain their tramways; they disputed figures concerning apparent tram loss making, but unfortunately the efforts to sway city officials, who prioritised other statutory obligations, would prove futile. Britain was only beginning to emerge from wartime rationing, and the city appeared to lack sufficient funds to maintain the trams as well as addressing more pressing social needs such as welfare, housing and amenities. Not surprisingly, new housing was located where land could be got cheaply, and since motor buses had become considerably cheaper, four could be purchased for the price of a solitary tram – finances rather than sentiment won the argument. A sign of revenue stress was the early 1950s selling of advertising space on tramcars not seen since District Co. days.

Inflation triggered a series of rises in fares, which had failed to catch up with the accelerating costs, meaning the funds were just not available for any system-wide investment. Financial woes were to the fore at a critical council vote in September 1952, when the elected representatives voted twenty-one against and thirty-one in favour of scraping the 47-mile network.

The system was closed down in stages, until the final tram ran on November 1956, an occasion marked by an estimated 100,000 turning out to bid farewell to what was evidently Edinburgh's most cherished form of transport. Strangely, the timing coincided with the Suez crisis, the first oil shock, causing cities such as Glasgow to at least pause severing their tramway ties.

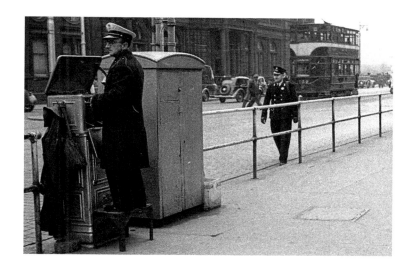

Points being manually controlled outside Register House; in later years, a booth was provided. (Dewi Williams)

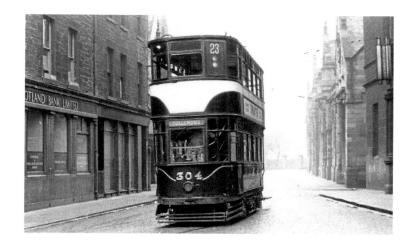

Car 304 outside of the ornate Tollcross depot. (Richard J. S. Wiseman)

Well-patronised trams on chilly-looking Princes Street. (Dewi Williams)

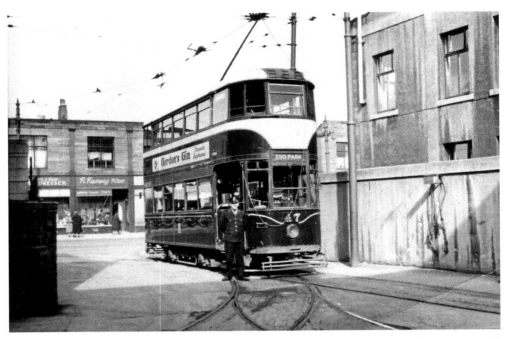

A driver poses with his zoo special at the Corporation's largest depot, Leith. (Richard J. S. Wiseman)

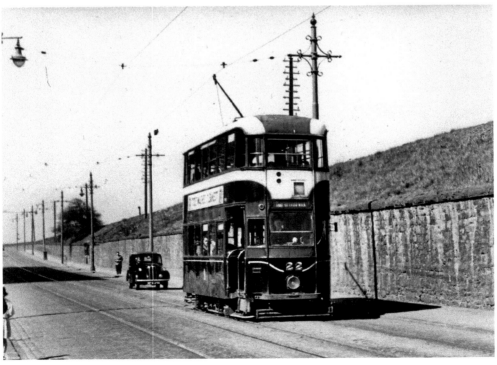

A Leith-bound Streamliner on Lower Granton Road. (Simon Fozard collection)

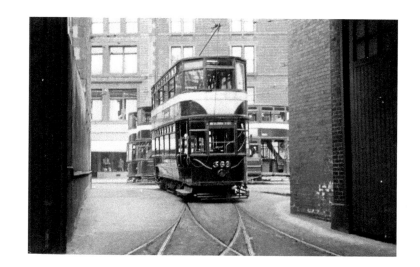

Portobello depot departure, early 1954. (Richard J. S. Wiseman)

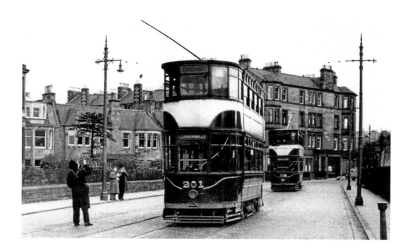

A conductor swings his trolley for the return journey. (Simon Fozard collection)

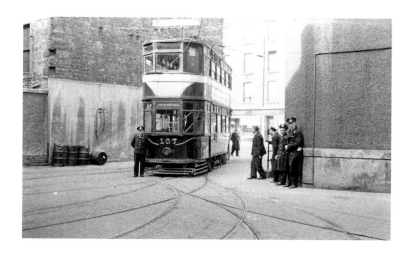

A driver poses for a picture at Portobello, April 1955. (Richard J. S. Wiseman)

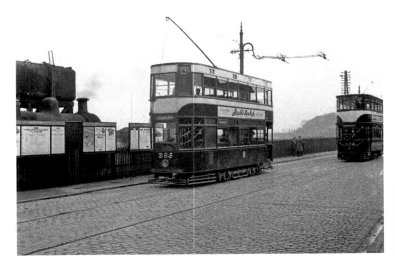

Granton station; trams and train services would be replaced by buses within a few years. (Simon Fozard collection)

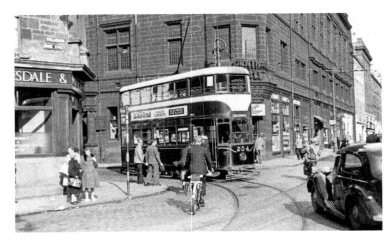

Car 204 returns to Tollcross depot; the conductress is ready to reposition the trolley. (Richard J. S. Wiseman)

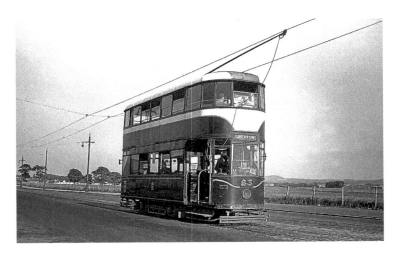

Car 83 on route 7 racing through a semi-rural-looking Liberton. (Norman Hurford, Peter Brabham collection)

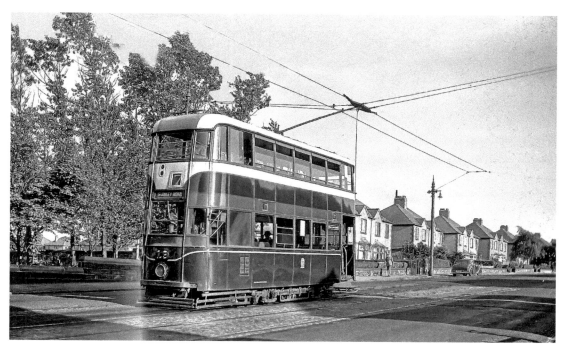

Streamliner Car 13 at Liberton, about to return to Stanley Road. (Norman Hurford, Peter Brabham collection)

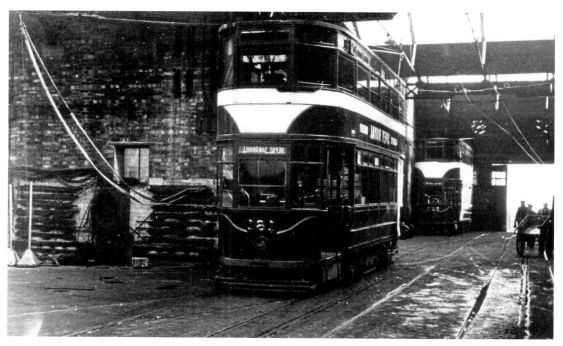

Car 161 at Portobello depot, April 1954. (Richard J. S. Wiseman)

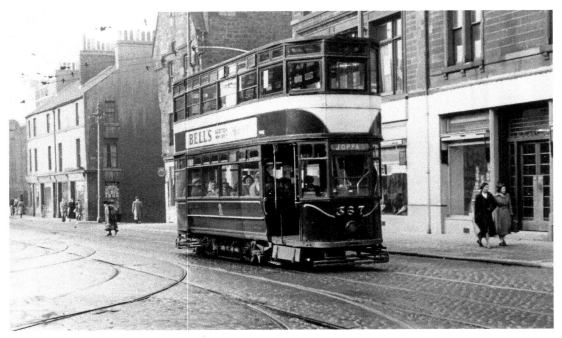

Car 367 passing Portobello Bath Street depot, 1953. (Richard J. S. Wiseman)

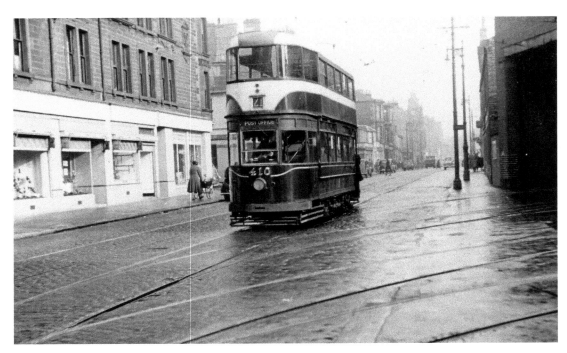

Car 410 pictured passing Bath Street depot. Ex-Manchester cars were known as 'Pilchers'. (Richard J. S. Wiseman)

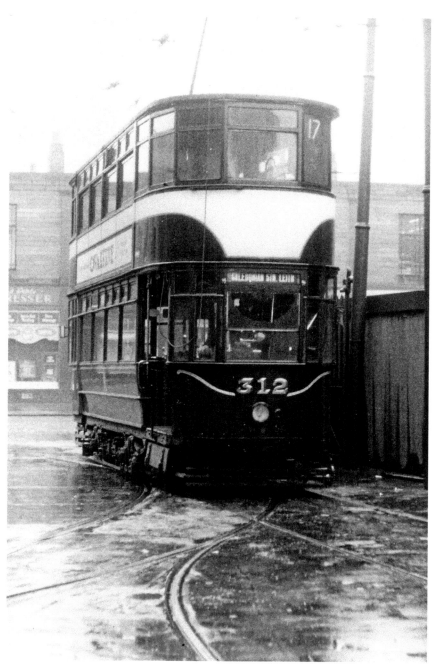

Car 312 about to leave Leith depot. (Richard J. S. Wiseman)

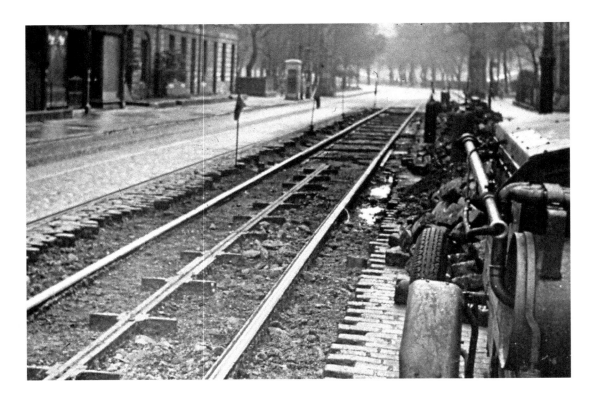

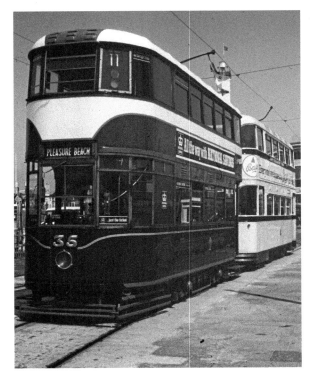

Above: Cable conduit being dug up, to be followed soon after with the entire line. (Tramway and Light Railway Society)

Left: The sole remaining electric Edinburgh Car 35 at Blackpool centenary (July 1985), now at Crich National Tramway museum. (Author's collection)

4

Changing Transport Policy Environment

All UK cities, with the exception of Blackpool, scrapped their tramways and invested in bus fleets. The railway closures ensured Edinburgh lost what suburban railways it had in the 1960s. Edinburgh's population continued to grow, from the 222,000 of the horse era to today's enlarged borough of 485,000; forecasts now predict 619,000 by 2037.

Population growth can only be accommodated with new housing. Edinburgh's only remaining housing development was within the vicinity of the Leith waterfront, where it was recognised that current bus infrastructure would struggle to cope with the demand of the anticipated extra population.

Car ownership, which previously was among the lowest in the UK, reached the national average, contributing towards extremely congested peak-hour traffic with bus journey times adversely impacted. During the 1980s, growing road congestion, along with concerns around imported fossil fuel and associated air pollution, meant that people began questioning the wisdom of Edinburgh's bus-dependent transport policy. As elsewhere, public transport lanes have been introduced, but for some time now the sheer volume of buses attempting to enter then traverse Princes Street has been leading to significant delays at the arterial east and west end junctions.

The first tram proposal came from the New Edinburgh Tramway Company in 1998, proposing a circular route between Haymarket and Newhaven via Princes Street, Leith Walk and West Pilton back to Haymarket; the route used a combination of on-street and former railway lines. An external report did not favour the proposal, which was never adopted despite the company chairman Professor Lewis Lesley's insistence that the project could be implemented without need for public infrastructure funds. NET Co. plans included deploying their shallow trackbed system (LR55), which did not require utility removal, thus making significant and financial time savings. Paradoxically, Lothian Regional Council's (LRC) *Edinburgh Area Public Transport Studies* of 1987–89 actually recommended establishing two new 'metro lines': east–west linking Leith to Westerhails via Haymarket and St Andrew Square, and separately north–south Liberton or Gilmerton–Muirhouse or Davidsons Mains, by extending the disused Scotland Street rail tunnel to emerge at Cameroon Toll. This significantly grander scheme proved prohibitively expensive, and again no go ahead was forthcoming.

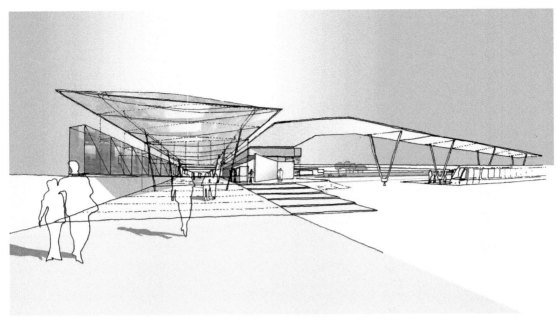

An artist's impression of Edinburgh Airport Rail Link station and tram halt. (AHR, formerly AEDAS)

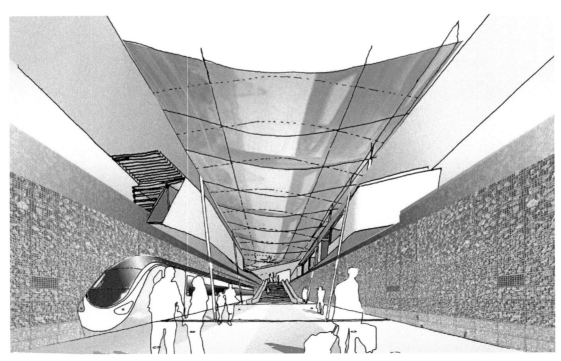

The station would have been the focus of four spurs from nearby main-line railways. (AHR, formerly AEDAS)

This left one of Europe's key heritage and top tourist destinations – with the world's largest arts festival, and booming conference, sporting and cultural events contributing to over 3.7 million visitors a year – fully dependent upon buses. Waverley station, the UK's second-largest, conveyed 18.9 million passengers in 2012–13; at the same time, Edinburgh airport handled 9.2 million passengers. Both are investing in their respective infrastructure to cope with forecast growth.

Airport Connections

Before LRC was dissolved, it handed over its unique Guided Busway project 'City of Edinburgh Rapid Transport' (or 'CERT'), among the earliest public transport schemes seeking to serve Edinburgh airport, to the new council. It was an innovation offering segregated busways, but it failed to ignite further investment. Interestingly, CERT's route was in the main the current Haymarket–Airport via Edinburgh Park station tram route.

Airports are viewed as strategic assets, vital for economic prosperity, and key generators of local public transport demand. Since airports often suffer from acute access problems, limited parking and peak-period congestion, the operators are therefore keen to attract rail connections with the cities they serve, representing as they do a means of reducing air pollution and traffic congestion. In 2001, Edinburgh's was one of the few UK airports without a direct rail connection to the city it served. By 2007 a separate new railway plan had emerged, known as the Edinburgh Airport Rail Link, EARL, a proposal to connect Edinburgh airport with the immediate rail network via a series of four separate tunnel spurs from nearby commuter rail links under the airport.

EARL envisaged an underground station where all the spurs met, offering immediate access to the terminal buildings above. The project would have been a major regional interchange; eight train departures per hour were envisaged, and forecasts estimated the services would account for 17 per cent of people using the airport in 2011, rising to 22 per cent by 2026.

The scheme championed by the then Labour-Liberal coalition with Conservative support was approved by the Scottish Parliament in April 2007. However, after the May 2007 Scottish Parliament elections, the new Scottish Nationalist Party (SNP) minority administration that had campaigned to scrap this scheme, having secured critical Green Party support, did so. EARL's demise was blamed on costs; lobbyists also cited duplication with existing bus services, longer intercity services, the fact that the Haymarket–Waverley line was working near to full capacity, and fears that questionable tunnelling conditions might cause cost overruns. Costs were estimated at £610 million, the station alone at £100 million; at the time of cancellation, taxpayers wrote off an estimated £30 million.

Had EARL proceeded, Edinburgh might have had a choice of two permanent ways to the airport. They were meant to work with one another; the railway would not have been able to maximise city patronage like the tramway, but the prospect clearly existed for overcapacity to and from the airport. Ministers did confirm that a new rail-tram interchange would be built, i.e. Edinburgh Gateway, enabling interchange with the Waverley–Fife Circle line.

Under opposition party pressure, the SNP minority Scottish government agreed the necessary funding package needed for the proposed new tram project between Newhaven (where the

latest housing development was located), the city and Edinburgh airport. Edinburgh council was to provide the balance, and the line was anticipated to be opened by 2011.

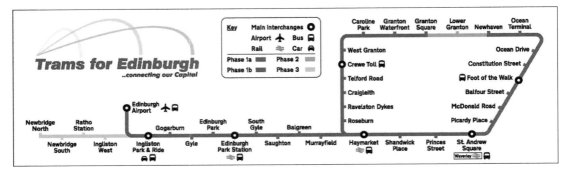

Original route plans. (Transport Initiatives Edinburgh)

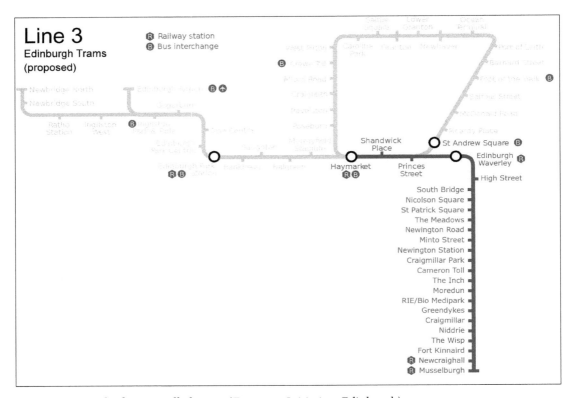

Line 3 was the first cancelled route. (Transport Initiatives Edinburgh)

5

Trama!

In the council's tram electrification vote of December 1920, members argued 'that it was impossible for Princes Street to carry all the traffic of greater Edinburgh', yet a hundred years on Princes Street has exceeded everyone's expectation, and now funnels over 400 peak bus movements per hour. In 2011 the council commissioned Jan Gehl, an acclaimed Danish urban design architect, to look in to Princes Street. He reported that the famous mile-long street was functioning as 'one big bus station', pointing out that it could not live up to its full potential because pedestrians were deterred by intense transit activity. Gehl proposed restricting this artery to trams and cyclists, which was the basis for creating a revival through an emerging shopping, tourist and café culture.

Gehl's vision has not been implemented, partly because the plan would create bus chaos and entail radical route redesign and possible knock-on congestion in the surrounding central zone. Edinburgh has one of the country's most acclaimed bus services, but despite this car ownership has surged to 54 per cent of city households. Car congestion and worsening air pollution, together with the need to increase labour mobility, were powerful arguments for supporting the reintroduction of rapid transit. Recognising that tramways would be expensive and potentially disruptive, because of the requirement for all the long-lost expertise to be bought in, the council established Transport Initiatives Edinburgh Ltd (TIE) in 2002. TIE was intended as an 'arms-length' non-profit public-private partnership body, and was charged with managing and delivering a wide spectrum of transport-related projects, such as EARL and the Edinburgh vehicle congestion charging referendum, to name but two.

From the council's perspective, trams were originally viewed as part of a wider strategy, including reopening old rail routes, new park and ride facilities, and outer- and inner-city vehicle charging zones. Congestion charging proved to be a highly controversial issue, marked by a period of intense political lobbying and heated debates. The newly elected minority SNP government having campaigned to abolish congestion charging and EARL, they did so, but failed to secure the necessary votes to scrap the tram project. Edinburgh voters rejected congestion charging by 74 per cent in 2005. Losing congestion charge revenue had severe implications, not least being how the council could possibly afford to fund future tram development.

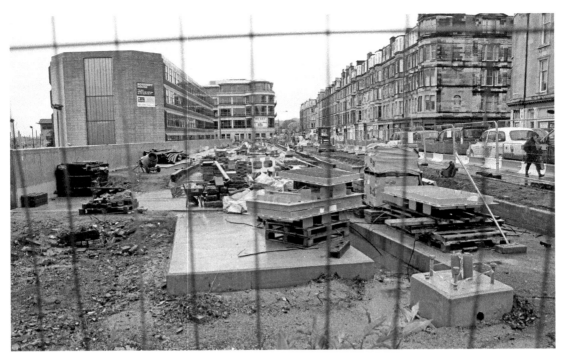

Tram works at Haymarket. (Glenn Innes)

Tram works on Princes Street. (Glenn Innes)

Proposed Tramways

TIE had been working on several principal tramway routes. The original 2003 proposal concerned transport from the airport to the city, in effect airport to Newhaven via Leith Walk and Princes Street. Phase 1b proposed linking Haymarket to Granton, via Roseburn and Crewe Toll, utilising disused railways. Phase 2 would have linked Granton to Newhaven, thus completing a northern loop with Phase 1b. Also, a proposed Phase 3 was for a spur line from Gogarburn to Newbridge, and finally an extensive line from the airport to Newcraigall, line 3, which would effectively be a southern branch line off Phase 1b towards the east end of Princes Street.

Newcraighall line 3 was dropped, an early casualty of losing the congestion charge income, leaving TIE to project-manage four distinct developments:

Phase 1a twin tracks of 19 km linking Edinburgh airport to Newhaven.

Phase 1b linking Haymarket to Granton.

Phase 2 was the northern loop's missing link of Granton–Newhaven.

Phase 3 was for a branch line from Gogarburn to Newbridge.

The Scottish government's watchdog body Audit Scotland agreed with TIE's cost estimate of £545 million, of which a £500-million infrastructure grant was anticipated to come from the devolved Scottish Parliament. Fortunately the council already held much of the required land, thus reducing exposure to compulsory purchase. In 2006 the SNP Government reluctantly approved a bill and a funding package for two lines. The remaining routes had a forecast of 11 million trips per year and a target launch date of 2009.

During 2007 TIE began awarding fixed-priced contracts. In theory such contracts were designed to defer project risks from TIE to the contractor. Belated media comment suggests critical mechanical, electrical and civil engineering aspects of the project were not completed prior to contract award. Carillion were awarded the preparatory works and service diversions, focusing upon the clearing of underground utility services within the proximity of the line, with a view to starting initial construction work in July 2007. This project was initially a fixed-price arrangement worth around £40 million, but for reasons detailed below it escalated to £65 million and critically added twelve months to project slippage. By December, Germany's Bilfinger Berger and Siemens had been appointed as the main project design and construction contractors (BBS); Spain's CAF won the tram rolling stock tender.

Work commenced in summer 2008, the plan being to construct the two lines in four separate phases, but even at this early stage costs were escalating. By December 2009 media reports suggested that the full budget had already been exceeded, no completed lines were evident, and estimates suggested that the earliest operations could not commence before February 2012.

In addition to general project inflation, there appear to have been underestimates relating to utility removal. Carillion's experience confirms that the mapping of underground utilities was incomplete; most related to new finds, but significant inaccuracy was uncovered, e.g. services

Above left: A tram protestor continues campaigning. (Glenn Innes)

Above right: An indicator of the ill-feeling towards the project. (Glenn Innes)

Reinforcing the point that the current route only serves one commuter corridor.

were not where they had been assumed to be. The original utility survey expected 190 chambers, but 295 were removed; the survey estimated 27.2 km of duct pipe work, but in fact contractors had to install 46.5 km.

A 'dig' in a heritage city often reveals the unexpected, since it is difficult to predict what is under decades of development. In addition to visual inspection, the survey would have culled information from numerous legacy sources such as utilities, but that meant trusting that historical groundwork contractors had continually relayed accurate information over many decades. In practice, utilities were not found where they were assumed to be; also, delays occurred with finds such as the Crawley Aqueduct and various Georgian cellars under Princes Street, a cemetery containing 390 bodies under Constitution Street in Leith, under Elm Row the remains of a sixteenth-century leper hospital, and a long-forgotten underground cable pulley room that emerged near Haymarket. Ground finds outside of town revealed a Dark Age settlement at Ingliston, a medieval village at Gogar, and then an unexploded bomb near the airport.

Under normal conditions, contractors are obliged to work around obstacles until they are removed or, in the case of archaeological finds, chronicled. This does not appear to have been the case in Edinburgh, as delay added to project costs no matter what the cause.

With limited resources, Edinburgh council were forced to accept the cancellation of entire sections. Phase 1b Haymarket–Granton Square, then phase 2 Granton–Newhaven were reluctantly dropped, but still costs increased; the original summer 2011 completion date deferred to 2012, then 2013. TIE needed to make deep cuts, so arrangements for French tram operator Transdev to run trams were cancelled, but cuts continued until all that remained was the airport–city trunk line, but even that was not guaranteed to reach Princes Street.

For prolonged periods, the high-profile Princes Street and West End tram works appeared abandoned, with little or no sign of progress. It was already known that the route would be dug up twice, once to effect utility removal then again to lay the deep track foundation; Shandwick businesses were not amused when their line was dug up a third time to be relaid. Several road closures had actually resulted in city centre gridlock. Not surprisingly, the media, politicians and public pressure rounded on TIE, who were becoming increasingly at loggerheads with the main contractor consortia, to resolve matters. Finally, in August 2009, TIE was compelled to commence legal action against the consortia over mounting delays.

Not surprisingly the evident gamesmanship took a toll on TIE's team – no less than three chief executives and three chairmen were appointed in succession. In November 2010, TIE Chairman David Mackay resigned, famously dubbing the project 'Hell on wheels' and Bilfinger Berger 'delinquent contractors'.

The council was alarmed at the mounting cost and delays, and arranged for external arbitration to mediate between the contractors and TIE. The arbiters duly investigated the mammoth contracts, all containing many expertly crafted clauses, and they found in favour of BBS, who were awarded a £80-million settlement. The council response was to disband TIE. The firm effectively ceased to exist after August 2011, with Transport for Edinburgh (TfE) now charged with tram operations along with their bus services.

The city now faced a stark choice: borrow more money to complete something or risk the potentially greater liability of paying off contractors, leaving unfinished infrastructure, and

Abandoned contractor signage.

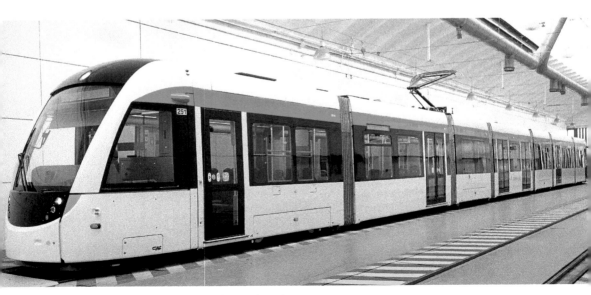

The first built tram ready for delivery. (CAF)

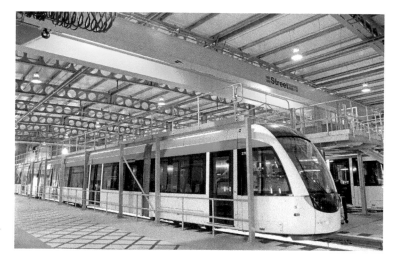

Fully equipped engineering facility at Gogar Depot, with overhead crane and inspection bays. (Courtesy of Street Crane)

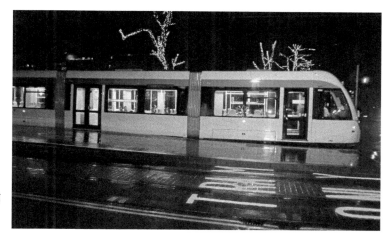

First tram passing St Andrew Square heading to York Place, early on 5 December 2013.

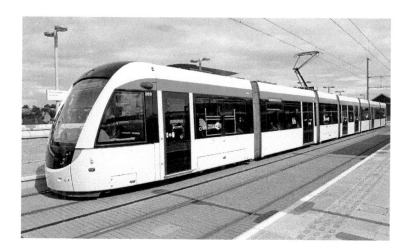

Urbos 3 at Murrayfield stadium.

lasting commuter blight, not to mention damaged civic pride. The council voted to complete a tramway, and David Anderson, director of Edinburgh City Development, summarised the rationale for proceeding with the new tram project thus:

> The Edinburgh Tram project will make a positive environmental contribution to the city's future growth by mitigating the forecast increase of 1 million vehicle kilometres per day, anticipated by 2020.
>
> The tram will also help the city to cope with the increased demand for public transport connections into the city by airport users (forecast to rise from 9m to 13m at Edinburgh Airport by 2020) and from the 40% forecast rise in rail passenger volumes, that is anticipated from the enhanced capacity on central Scotland rail.
>
> *The Scotsman*, May 2011

A short time later, funds had been confirmed to ensure the line's extension to York Place to serve as the final terminal.

Project Criticism

Bringing back trams to Edinburgh has proved to be a highly politicised and divisive project that has left much acrimony in its path. The scheme has never been remote from critics, and some have been damning in their assessments, dubbing the scheme a council 'vanity project', or claiming that the 42-metre-long super-trams were too large to penetrate a city of Edinburgh's nature, and that key junctions with road traffic, specifically Haymarket, Princes Street, Shandwick Place and Hope Street, where traffic controls would be manipulated in favour of approaching trams, would lead to lengthy queues of standing traffic, creating frustrated drivers and spreading congestion and air pollution from the thoroughfares to nearby residential streets.

Lobbyists and residents have not been slow to voice their disapproval and frustrations, which continued during the concluding phases long after TIE's demise. It is worth reminding ourselves what the trams were intended 'to support and promote a growing local economy and create a healthy, safe and sustainable environment for Edinburgh.' (Auditor General for Scotland and Accounts Commission, February 2011)

In June 2014 the devolved Scottish Parliament announced that a judge-led enquiry would be held to determine why the tram project had been delayed and cost so much, no doubt looking into contractual supplier relations and managerial aspects; hopefully this will provide answers that will enhance the prospect of future projects or expansion schemes, avoiding a similar fate. Meanwhile there remains much unfinished business in the wake of the first line opening; the most obvious is that only a single commuter corridor is enjoying any benefit. Others still need addressing, as do outstanding issues such as the sheer number of city-centre bus movements and possible knock-on inner-city traffic displacement.

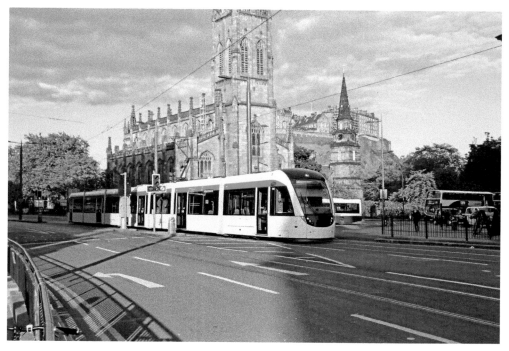

Trams back in the West End after fifty-eight years.

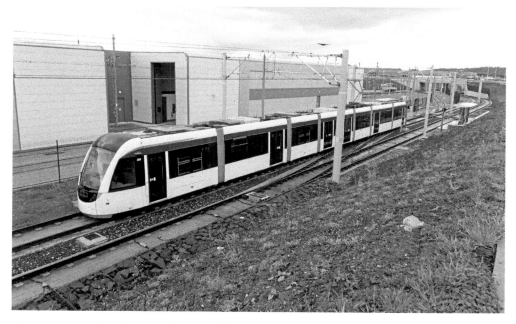

Car 252, pictured on the initial test track between the depot and Gogar halt in 2013, displaying the current Lothian Buses scheme (i.e. gold instead of platinum), itself derived from the Corporation-era trams. (Kyle Hulme)

The TfE and council campaign to raise awareness of the new tram service.

Launch and Early Patronage

After prolonged and increasingly intensive testing, Edinburgh Trams Company (TfE's official operating tram company, abbreviated to ETC) finally opened to the public on Saturday 31 May 2014. The first trams ran to capacity, with a mixture of old and young, curious locals and tram enthusiasts. The busy launch weekend was followed by a testing sell-out concert at Murrayfield stadium. Over 130,000 trips were taken in the first week, and subsequent weeks reportedly averaged 90,000, which, if maintained, might ensure that the first-year patronage target of 4,555,000 and £7.9 million revenue are exceeded. Encouraging as this may appear, it is still early days and it will be some months before a clearer picture emerges. Even if the first-year target is met, TfE financial projections suggest the service will continue to run at an operating loss until 2029. Certainly, the targeted 11 million annual tram trips is an ambitious goal for a solitary line.

Future Expansion

Designed to cater for significantly greater route miles, the depot, fleet and associated infrastructure are working at well under capacity and clearly have potential for significant growth. Edinburgh can take some consolation from the knowledge that other new British tramways have implemented expansion plans within relatively short periods, but no other UK urban transport scheme has experienced such rampant project inflation, delay, controversy and acrimony as experienced in Edinburgh.

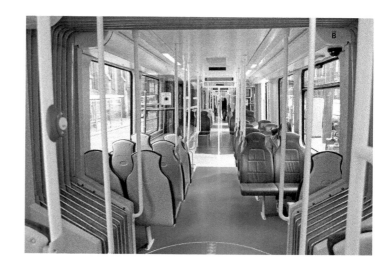

Interior of Urbos 3, bright with plenty of luggage rack space.

CAF Urbos 3. The central module offers excellent disabled access.

Free Wi-Fi was initially limited, but is now fleet wide.

In August 2014 it emerged that council interest payments on the tram-related debt were about £5.8 million a year. Therefore, even if patronage forecasts are met, the resultant revenue surplus will not be adequate to service the costs associated with line expansion, let alone to service existing debt, which begs the question how could future expansion be financed? The UK government, sponsors of the current £14.8 billion Crossrail scheme that attracted a financial contribution from Heathrow airport, views this as a matter for the devolved Scottish Parliament, but the SNP administration remains adamant they won't be a source for future funding. Since the council has already taken on enough tram debt just to ensure the existing line was completed, this may prove an opportune time to look at alternative means.

Future expansion might be found in Edinburgh's past tram expansion success, where two contrasting approaches were adopted that might still retain some elements of merit. The long-term lease where the private company agrees to finance, build and operate the line takes the operational surplus for a defined period before handing back to the city any infrastructure it might otherwise not be able to afford to finance. To ensure investment is maintained, a suitable exit payment arrangement is agreed. Known as Private Finance Initiatives, a relevant recent example includes TramTrack Croydon, a partnership of investors, builders, and a tram manufacturer and operator. The partnership engaged with TfL on a ninety-nine-year lease, which was bought out after twelve years. By all accounts Edinburgh already has an excellent tram operator fully integrated with the bus network. Thus such a partnership, were it to materialise, might not require the operator or manufacturer partners required to initiate trams in Croydon.

A more pragmatic approach was demonstrated by the Corporation Transport Department between the wars, the era of the Wall Street Crash, high unemployment and the Depression. With virtually nil external funds, the Corporation built one of the largest British tramways as it forged ahead with electrification, line extension and even building their own trams. Among the many benefits included: retaining expertise, enabling apprenticeships to be offered and retaining wealth within the community.

The trams have parliamentary approval to extend lines down Leith Walk until 2021, and the council announced their intention to 'tram proof' works in the vicinity of cancelled routes so as not to adversely impact any future track build. Should trams reach the bottom of Leith Walk, it will be a peculiar resonance of history repeating itself, reviving as it would the majority of the Haymarket–Leith tramway originally pioneered by the enterprising horse buses and first horse tramway some 150 years previously.

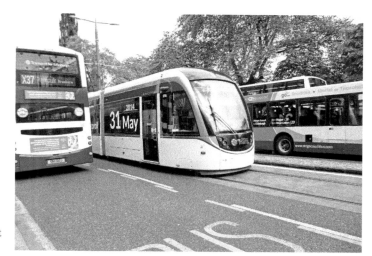

Readytoroll day, announced
by a test tram in Princes Street
traffic.

Platform information now
offers updates about when the
next trams are expected.

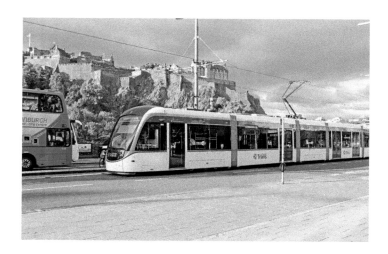

Edinburgh Castle from
Princes Street.

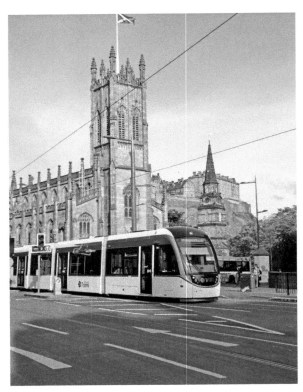

Left: Trams running past St John's, Princes Street, towards the West End.

Below: South St Andrew Street view.

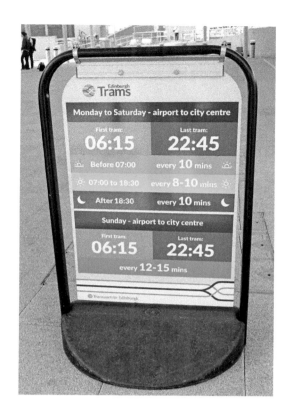

Airport schedule signage.

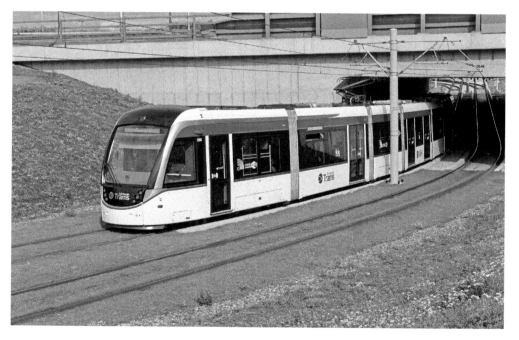

The tunnel beneath the A8 Gogarburn roundabout.

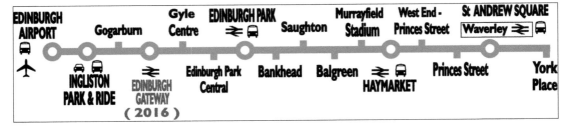

Map of current line.

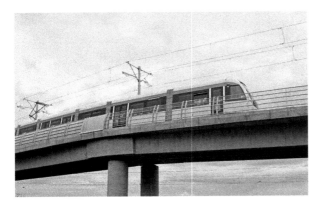

The bridge over the main East Coast rail line at Edinburgh Park.

Trams passing one another on the main railway bridge.

Between Saughton and Balgreen, the line crosses the main East Coast rail corridor.

Edinburgh's New Tramway

The cost escalation prevented the airport route termination at Leith Walk; at one point the city terminus was to be Haymarket, then St Andrews Square was quoted by the media as the city terminus, before the council confirmed the build finance to reach as far as the York Place terminus. So the following 11.5-mile section, largely of 'route one', formed the tangible assets after the £776-million investment concluded on 'readytoroll day', 31 May 2014.

The majority of the line is built off street on segregated double track of 4-foot-8½-inch gauge. Occasional road crossings occur on the Haymarket–airport section, and tram speeds are minimal between York Place and Haymarket, after which they do pick up significantly.

The New Trams

British tram manufacturing has long ceased, but trams were retained in Europe, so it's not a surprise that TIE awarded the Edinburgh contract to *Construcciones y Auxiliar de Ferrocarriles* (CAF) of Spain in September 2007. The contract was for the supply of twenty-seven state-of-the-art Urbos 3 super-trams, of which subsequently only seventeen were needed to service the shortened route. As Gogar depot was not handed over until December 2011, discussions were held with Croydon (TfL), who at the time had been reported as seeking additional tram capacity. ETC were looking for temporary housing and the opportunity to secure early driver training, but this, together with a possible sale or lease agreement for the surplus trams, has not materialised as yet.

The bidirectional Urbos 3 trams each weigh 56 tonnes, and are made up of seven modules (the shorter the module lengths, the tighter the turns achievable), mounted on four separate bogie units (thus three 'suspended' modules per unit). They are 2.65 m wide and 42.85 m long, with a passenger capacity of 250, with seventy-eight seats and two wheelchair places. These are all electric-powered units featuring 12 x 80 kw (110 hp) traction motors 750v DC, fed by a solitary roof-mounted pantograph, with a top speed of 70 km/h. There are no on-street carbon emissions, and a regenerative braking system ensures that some previously lost energy is purposely recycled.

This design enables a wheelchair-friendly layout and low floor access, due to much of the traditional beneath-floor 'kit' now being stored on the tram roof; the depot workshop, where

CAF are contracted to supply maintenance for thirty years, has been arranged accordingly. Internal display screens inform passengers of the next stop and carry advertising.

The trams were delivered in a white livery, featuring a top red line; this would have been a basis of a number of earlier artist illustrations depicting Lothian Buses' harlequin livery, but after adopting the current livery of madder, white and platinum, one unit appeared briefly with a gold style line. Two trams have not been 'wrapped' in the current colours; they await 'wraps' to be determined by the council. The twenty-seven trams have the serial numbers 251 to 277.

Clearly there couldn't be a wider contrast between the pre-1956 double-decker trams and the lengthy seven-module single-deck Urbos 3s. The latter are among the largest tram units in production, and the biggest in UK use. In terms of performance, speed, capacity and comfort, Urbos 3 are more akin to today's rail rolling stock than the final trams 'knocked out' at Shrubhill depot. At a time when most railway rolling stock is leased from private sector specialist rolling stock leasers, the fact that Edinburgh owns its trams, as in the 1950s, should be welcome news to public transport supporters.

Tram Timetable and Fares

Commencing services at 5.29 a.m. and running till 10.45 p.m. daily, the trams currently offer a frequency between eight and twelve minutes (twelve–fifteen minutes on Sundays); they average a journey time of thirty-four minutes between the airport and Princes Street, and thirty-nine minutes from the airport to York Place. ETC hope to reduce journey times by increasing average speeds once the service is established. Fare policy ensures tram travel is similarly priced to bus travel, with the exception of a premium-priced airport zone, similar to the Airlink bus express arrangements.

At the time of going to press, the Edinburgh's dedicated Waverley–airport express Airlink 100 offers a thirty-minute service at £4 single (£7 return), a high-frequency service typically with seven minutes between departures. If the N22 night service is taken into account, this is a 24/7 service travelling directly along the A8 for a distance of 12.7 km. The trams follow a broadly similar route, except the 'dog-leg' route to Edinburgh Park, edge of Hermiston Gaite Retail Park, which is a length of 13.9 km. Since York Place is that bit further down the line than Waverley bridge, we are clearly not matching like with like.

Terminus and Halts

The architects have imposed a standard design throughout the route, with each halt featuring a sleek brushed stainless steel shelter, seating, ticket machine and bins reflecting the same choice of material. Although not extensive, the seating on offer is robust yet not aesthetically out of place, both sheltered and exposed. The platforms allow same height access for prams and wheelchairs, and every platform is covered by CCTV and equipped with disabled-friendly intercoms with tram control.

1. York Place
The isle platform located at the end of Queensferry Street offers a mixture of office, tourist accommodation and bus interchange. The halt is only about 100 m from the originally planned

An introduction to TfE at Edinburgh airport.

Picardy Place at the top of Leith Walk, being the planners' choice for a halt here, thus York Place is a compromise location. Acting as a terminus, it has a switchover line.

2. St Andrew Square
A significant number of offices are within walking distance, including the Bank of Scotland, as are the Harvey Nichols store and Edinburgh bus station (long-distance coach and intermediate bus services) and this is the closest service point for Waverley station.

3. Princes Street
Princes Street has served as a destination and interchange with other services since the pre-horse tram days of public bus services. The isle platform is located midway along Princes Street besides the Scottish National Gallery on the Mound, within walking distance of all other bus and coach services that stop on or near here. Princes Street remains a popular shopping, tourist and business destination in its own right.

4. West End Princes Street
Known to locals as Shandwick Place, this halt is central to the busy West End offices; a beautiful row of mature trees was removed to ensure clearance for overhead wires. The line has a switchover here, enabling airport services to continue when Princes Street remains closed for street parties or other festive events.

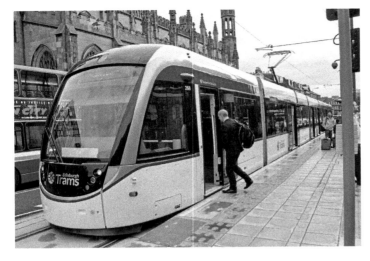

York Place terminus.

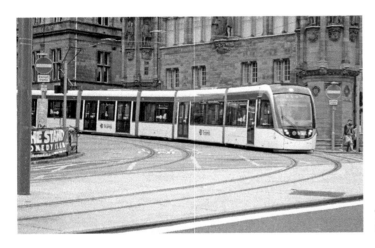

Turning down North St Andrew Street on to York Place.

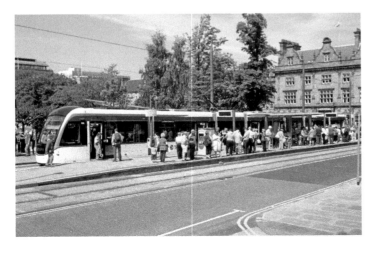

St Andrew Square on launch day, 31 May 2014.

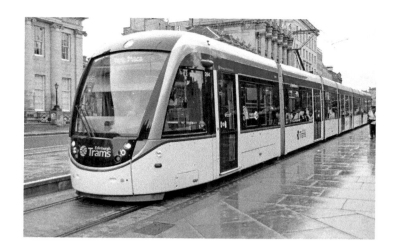

St Andrew Square in the drizzle.

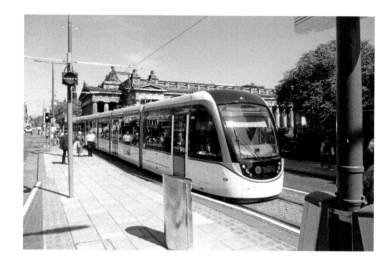

Approaching Princes Street.

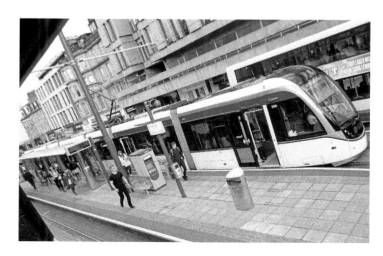

Princes Street tram halt in morning rush hour.

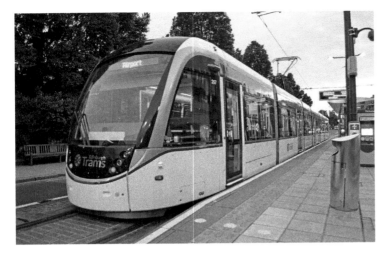

Princes Street after rush hour.

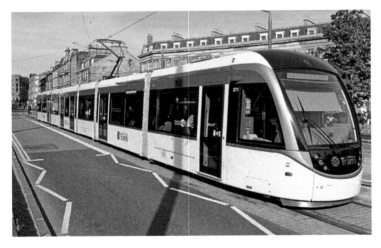

West End Princes Street or Shandwick Place.

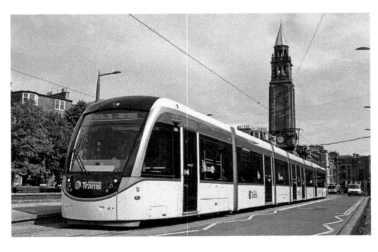

West End Princes Street arrival.

5. Haymarket

Upon leaving the parallel course with the railway, the line enters street traffic, which continues to York Place. A flanked platform offers immediate interchange facility between tram, bus and Scotland's fourth-busiest railway station, and for many it is a destination in its own right due to the considerable adjoining office and hotel capacity. If Airport bound, Haymarket represents a quicker interchange than a Waverley switch via St Andrew Square, unless passing Edinburgh Park and Edinburgh Gateway.

6. Murrayfield Stadium

Serving the famous stadium and surrounding housing development, this is the home of Scottish rugby, but is also used for concerts and exhibitions. Of all the halts, due to its elevated position above the stadium access roads, Murrayfield has more of a main-line station appearance, yet its layout with flanked platforms is very similar to others. The exception is the thoughtful inclusion of a disabled access lift on the elevated embankment, necessitating a flared step and handrail arrangement required for stadium-related events.

7. Balgreen

A dense housing suburb facing the famous listed Jenners Furniture Store (John Lewis). Edinburgh Zoo, Water of Leith Walkway and Saughton Park are within walking distance.

8. Saughton

Saughton is a western housing suburb. The halt additionally serves neighbouring Stenhouse, Carrick Knowe and Saughton House, a Scottish Government facility.

9. Bankhead

This halt serves the adjoining industrial estate and the Sighthill campuses of Edinburgh College and Napier University, as well as the western end of Broomhouse housing estate.

10. Edinburgh Park Station

Interchange with the Waverley/Haymarket railways offering direct access to many central belt destinations. Also on hand for Herminston Gaite Retail Park, Edinburgh Park business park and two large chain hotels. There remains much significant development land with in walking distance suggesting significant growth potential.

11. Edinburgh Park Central

This is the principal halt for Edinburgh Park business park. The tramline takes advantage of what was originally a screening landscaped feature. The South Gyle shopping centre is also a short walk away.

12. Gyle Centre

The tramline crosses South Gyle Broadway in diagonal fashion. Traffic lights are again biased towards tram movements. The Gyle is all about retail shopping, so this location principally serves that function. The location may also suit commuters seeking the northern end of the Edinburgh Park business park.

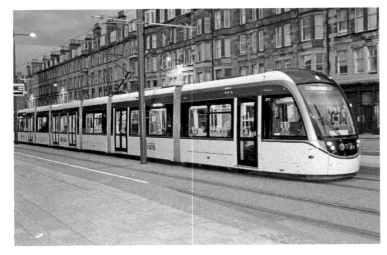

Haymarket at night, with Car 271.

Murrayfield Stadium station has ample crowd barriers.

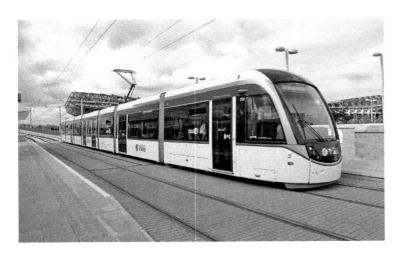

Car 252 departs from Murrayfield Stadium station.

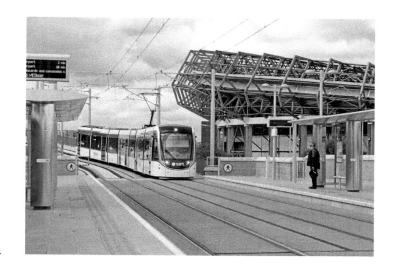

Tram arrives at Murrayfield.

Murrayfield between events.

Crowds descend for a
Murrayfield evening event.

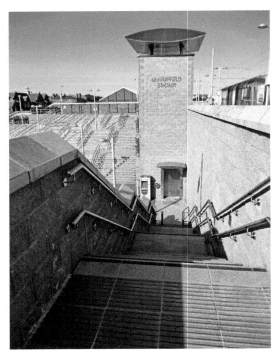

Left: Murrayfield Stadium station. There is a major emphasis on crowd control for big occasions.

Below: Balgreen departure.

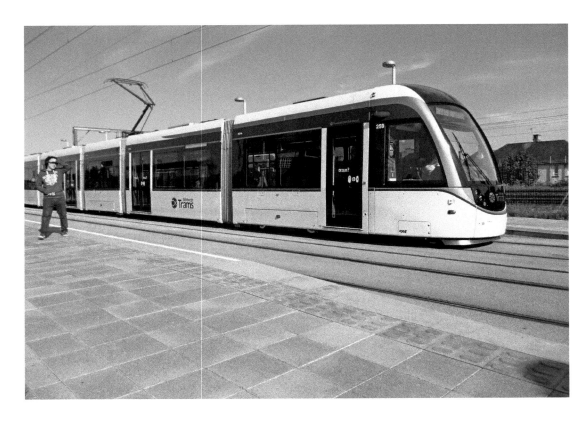

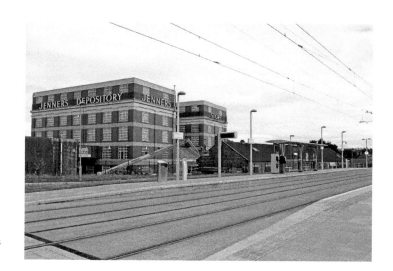

Balgreen station and Jenners Depository.

Balgreen signage, similar throughout the network.

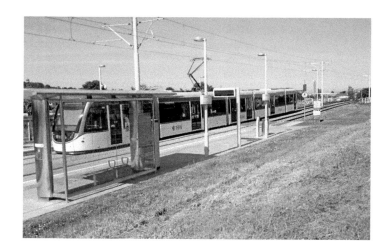

Saughton departure.

Saughton arrival.

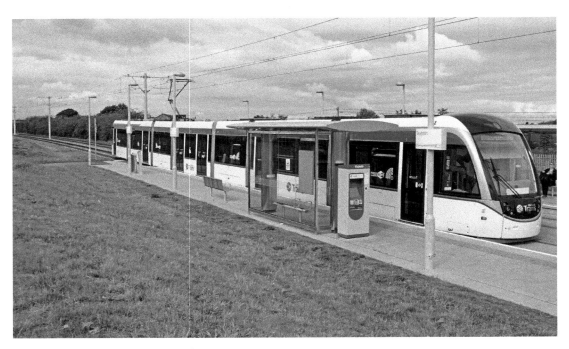

Saughton station view from the west.

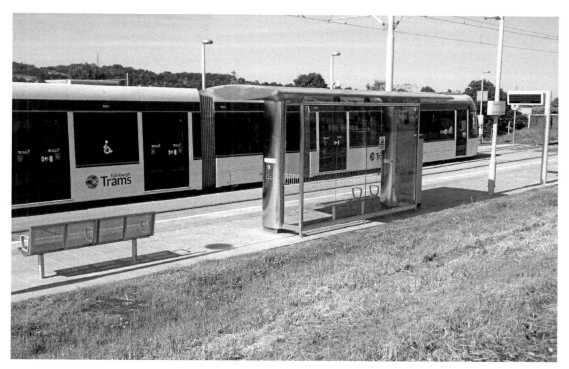

Saughton station view from the east.

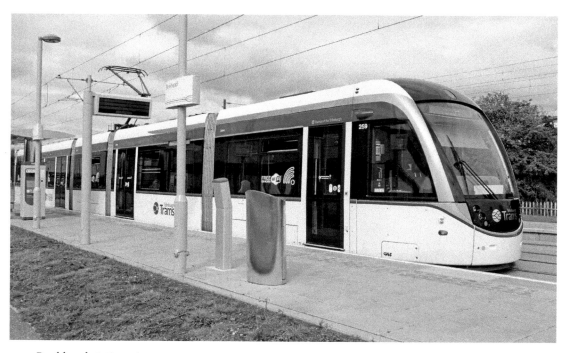

Bankhead station view.

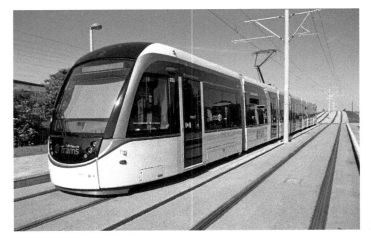

Bankhead arrival.

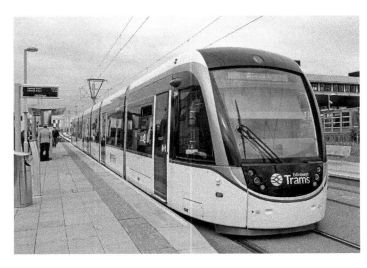

Readytoroll at Edinburgh Park station.

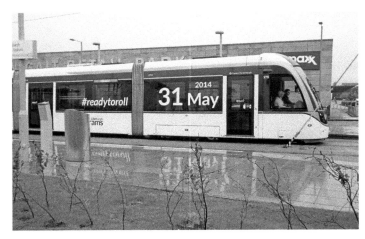

Edinburgh Park station interchanges with the adjoining railway.

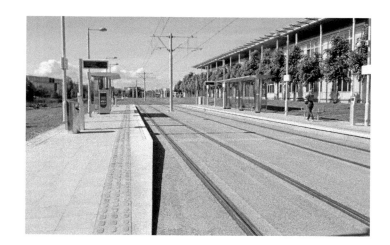

Edinburgh Park Central looking north.

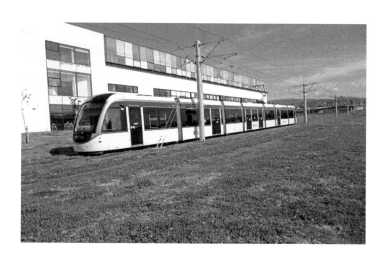

Edinburgh Park Central looking south.

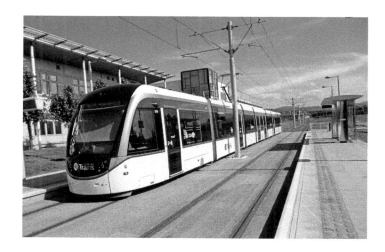

Edinburgh Park Central departure.

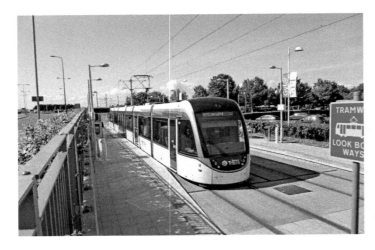

Gyle Centre airport departure.

13. Edinburgh Gateway (under construction)
A £30-million project managed by Transport Scotland on behalf of the Scottish Government. Ground investigations have commenced on this future interchange, which is expected to be complete by September 2016, connecting the Fife Circle with the tram network. Once open it will add no more than about twenty seconds to the journey time.

14. Gogarburn
Mature tree screening here gives the halt a distinct rural feel. In fact it serves a singular function of transit to and from the RBS bank headquarters, which is reached by the combined pedestrian road bridge over the busy A8 dual carriageway.

15. Ingliston Park and Ride
This is one of several Park and Ride locations around Edinburgh's periphery, designed to encourage city-bound car commuters to switch to public transport in the knowledge that parking is convenient to arterial road access, free and secure. The facility is used by commuters and off-peak users alike, and is reportedly busiest during city and Murrayfield events. Had the congestion charge progressed, this would be one of several such edge of city car interchanges, but now it remains unique.

16. Edinburgh Airport
This is the only premium-priced stop on the line. It now features a fabric-canopy-covered waiting area (opened in July 2014), which will connect with a covered walkway in to the terminal building. Despite the extensive waiting area in theory, ETC operations ensure there is a standing tram awaiting city-bound passengers.

Gogarburn Depot
In addition to being the ETC office, admin, control, workshop and fleet cleaner, this all-encompassing state-of-the-art building also has its own shortened flanked platform halt not intended for the travelling public, purely to facilitate staff access and tram staff changeovers; thus not every passing

Gyle Centre city-bound departure.

Edinburgh Gateway site, showing the proximity of the Fife railway service.

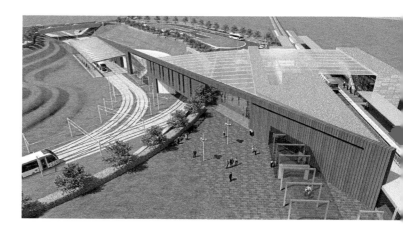

Edinburgh Gateway aerial artist's impression. (NetworkRail Scotland)

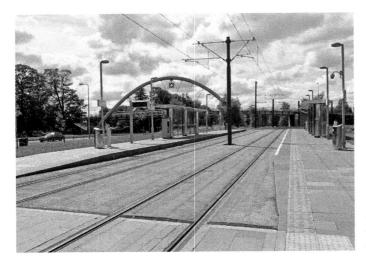

Gogarburn looking west, with a view of the bridge over the A8 to RBS HQ.

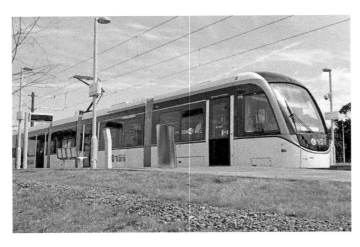

Gogarburn city-bound tram departs.

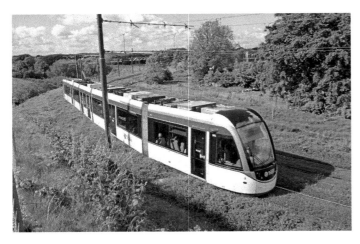

Leaving the tight Gogarburn turn in towards Ingliston P&R.

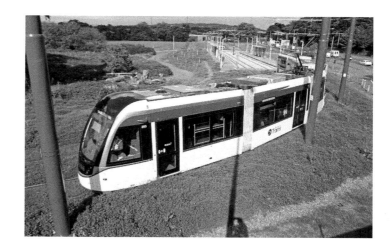

Gogarburn tight turn.

Ingliston Park and Ride looking east, with a local substation on the right.

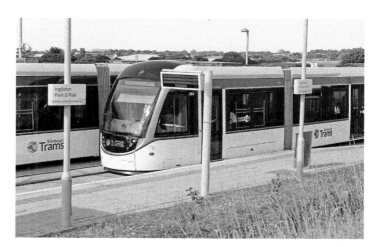

Passing trams at Ingliston P&R.

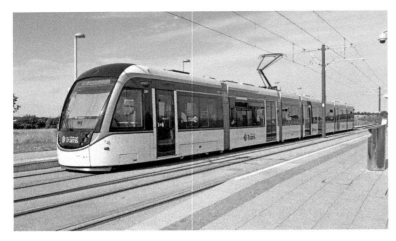

Ingliston Park and Ride departure.

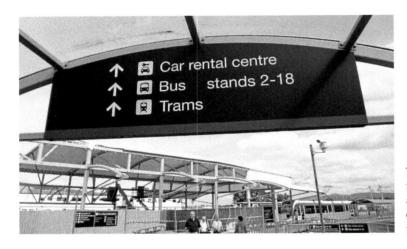

The airport tram terminal will have a covered walkway connection to the terminal.

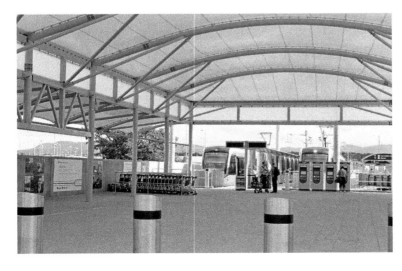

Airport tram waiting area.

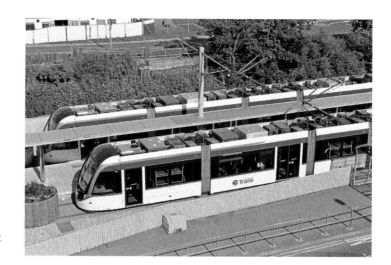

Looking down on the airport tram terminal.

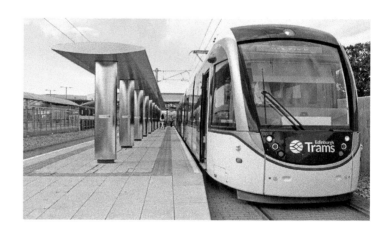

Businesslike airport tram terminal.

tram will stop there. This is a fully secure, CCTV-monitored, fully fenced facility enabling the parking of the twenty-seven-strong Urbos fleet. The establishment accommodates 130 workers, including the tram staff. The site has been 'burrowed' into the ground to ensure it cannot obstruct an airport flight path.

Tram Control Room
The tram control overlooks the east-facing side of the depot building. It is permanently manned during commercial tram operation, coordinating all tram movements, signals, CCTV (onboard, tram stops and key points), radio to drivers, staffing during ops, and tram traffic light priority.

Workshop
Operated by CAF on a thirty-year contract, the workshops can accommodate six full-length Urbos 3s. An overhead crane ensures ease of substituting any heavy roof-mounted devices.

Tram Wash

The tram wash, in addition to keeping the trams clean, offers an additional environmental plus of recycling the depot's grey water, which is stored for this purpose.

Electrical Substations

There are six electrical substations, located at: Ingliston, Gogarburn (within the depot complex), York Place (Cathedral Lane – behind the main road), Haymarket (below ground level), the Jenners Depository at Balgreen Road and beside Bankhead Halt.

Ticketing

Ticket vending machines have been supplied by Parkeon; since they also supply Lothian buses, this ensures interchangeability. The vending machines accept coin and card payments, but not cash notes. All trams have a ticket services assistant (conductor) with the aim of checking all tickets; non-ticket holders or invalidated briefs can and will attract a £10 fine. Such messaging is repeated on tram PAs.

Fares

The tram service has interchangeable ticketing with Lothian buses; both are now integral components of Transport for Edinburgh. Limitations include the 'airport fare zone', which charges users a premium for services to and from that terminal. Over-sixty concession cards are limited to those issued by Edinburgh council.

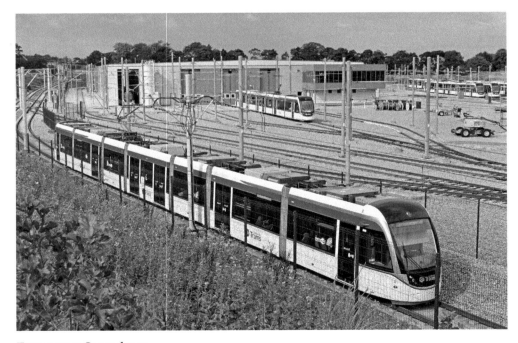

Tram passes Gogar depot.

The multi-task Mercedes Unimog: winch, rail cleaner, and four-wheel drive snowplough.

Attachments for specialist maintenance.

Raised access from rail or roadside.

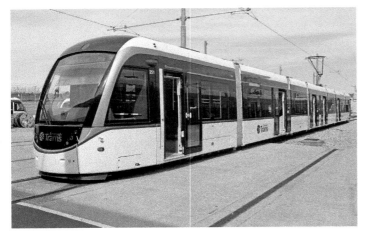

Gogar tram depot. Tram 251 'chills' prior to joining the next peak period.

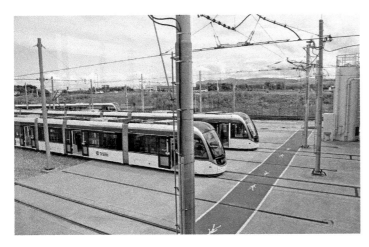

Gogar tram depot south yard view.

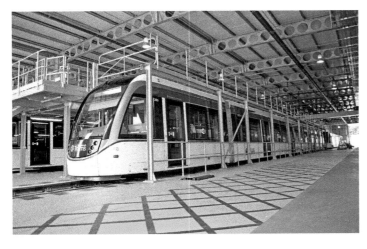

Gogar tram depot CAF workshops.

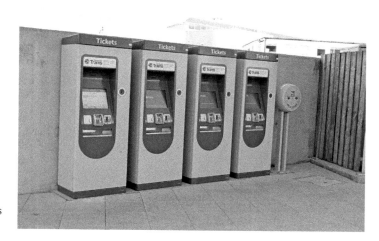

Additional ticketing machines at the airport terminal.

Right: Standard platform furniture: stainless steel bin and anti-vandal ticket validator.

Below: A spur trackbed near Murrayfield, intended for the Phase 1b line to Granton Square.

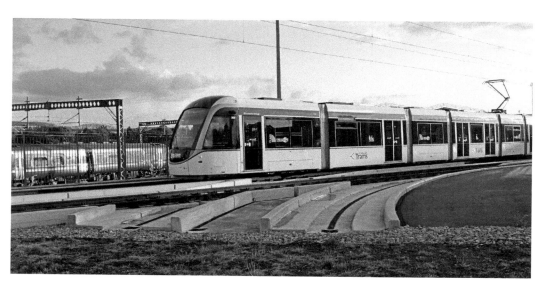

Bibliography

Cassells, *Old and New Edinburgh* (London, April 1803)

Duncan's Manual of British & Foreign Tramway and Omnibus Companies (T. J. Whiting & Sons, London, 1894)

Edinburgh Area Public Transport Studies, 1987–89

Hunter, D. L. G., *Edinburgh's Transport* (The Advertiser Press, Huddersfield, 1964).

Hunter, D. L. G., *Edinburgh's Transport Volume Two: The Corporation Years 1919–1975* (Adam Gordon)

Incorporated Association of Municipal and County Engineers, *Edinburgh Northern Cable Tramways, Volume XVII* (William Newby Colam Proceedings, London, England, 1890–91)

Lee, Charles Edward, *Horse Bus as a Vehicle* (London Transport, 1974)

'Municipal Trams', *Fabian Tract Number 33* (The Fabian Society, February 1898)

Scottish Transport, the Scottish Tramway Museum Society – past issues of *STTS* and www.scottishtransport.org

Sinclair Knight Merz, *Rail Links to Glasgow and Edinburgh Airports* (The Scottish Executive, Feb. 2003)

The www.scotsman.com digital archive

Wiseman, R. J. S., *Edinburgh's Trams, The Last Years*, all four volumes (Stenlake Publishing, 2005)